KU-526-154

THE ART
OF
CHART
INTERPRETATION

Tracy Marks

CRCS PUBLICATIONS
Post Office Box 1460
Sebastopol, California 95472
U.S.A.

ACKNOWLEDGEMENTS

*Special thanks to David Perloff and Heidi Ruthchild
for their editorial and proofreading help,
and to Paul and Martha Marks, my parents,
for many kinds of encouragement.*

Library of Congress Cataloging-in-Publication Data

Marks, Tracy, 1950–
 The art of chart interpretation.

 Rev., expanded ed. of: The art of chart synthesis.
c1979.
 Bibliography: p.
 1. Horoscopes. I. Marks, Tracy, 1950–
Art of chart synthesis. II. Title.
BF1728.A2M39 1986 133.5'42 86-9683
ISBN 0-916360-29-6 (pbk.)

© 1986 by Tracy Marks

All rights reserved under International and Pan-American Copyright Conventions. Printed in the United States of America. No part of this book may be used or reproduced in any manner whatsoever (including photocopying) without written permission from the publisher, except in the case of brief quotations embodied in critical or scholarly articles and reviews.

INTERNATIONAL STANDARD BOOK NUMBER: 0-916360-29-6

Published simultaneously in the United States and Canada by:
CRCS Publications
Distributed in the United States and internationally by
CRCS Publications
(Write for current list of worldwide distributors.)
Cover Design: Image by Bradley Dehner

The Art of Chart Interpretation is a revised, expanded edition of a work formerly entitled *The Art of Chart Synthesis* (© 1979 by Tracy Marks). This new edition includes extensive new material, including redesigned worksheets and an entirely new Part III.

Quotations by Liv Ullman are reprinted from *Changing* (© 1976, 1977 by Liv Ullman), with permission from Alfred A. Knopf Inc.

Contents

Introduction

The dilemma that most of us face, after we have learned the meanings of the planets, signs, houses and aspects, and have begun to delineate the bits and pieces of the chart, is how to view the chart as a whole and determine its primary characteristics. The vast array of planets and aspects so easily becomes a dense jungle of twisted vines which prevents us from discovering the trail that leads out of the undergrowth, to the central meaning and purpose of the chart itself. Only by becoming so familiar with each of the multifaceted parts of the chart that interpreting the details becomes automatic, and only by consciously focusing upon the overall pattern and the chart's most outstanding characteristics, can we begin to master the art of interpretation and synthesis* rather than lose ourselves in the tangle of hundreds of interrelated variables.

Many of us, when we begin interpreting charts, feel that we must cover everything—every planet, sign, house and aspect. If we don't, we fear that we may be neglecting some-

*This book was in fact originally entitled *The Art of Chart Synthesis*. However, this new edition has been extensively revised and expanded, including redesigned worksheets and an entirely new Part III, as well as many other substantial improvements and clarifications.

thing important, or failing to give a complete picture of the influences operating at birth. But in covering everything, we often end up covering nothing, because we fill our minds and our clients' minds with so many minute details that all that remains for all concerned when the reading is finished is a foggy blur.

Some of us may approach a chart by interpreting it house by house, beginning with the first house and moving counter-clockwise around the wheel. Others may begin with the Sun and consider every planet in turn—Moon, Mercury, Venus, etc. Still others may attempt to transform chaos into order by considering each area of life important to the client—love, work, home and family, etc., and interpreting all the planets, signs and houses associated with it.

These systems of interpretation may work for some astrologers and some clients. But they lack an essential element necessary to giving a meaningful reading—attention to priorities, to the central meanings of the chart above and beyond its multifaceted characteristics. Without this focus, the most prominent issues of the chart are likely to be lost in an array of minor issues. Without this focus, clients have nothing to grab onto to help them relate all that is told to them in a meaningful and unified way; as a result, they forget most of it or consider it in only a superficial manner. Covering everything does not help clients to assimilate everything; most often, it overwhelms and confuses them, so that they are less sure of their identity and direction when they leave the room than when they entered.

If we want our clients to emerge with clearer mental pictures of themselves, including the understanding of their predominant strengths and talents, and the weaknesses and conflicts which can become strengths and talents once they develop the desire and resolution to transform them, we must aim for quality and depth of insight in our readings rather than quantity and breadth of scope. After we have spent at least an hour on the most distinctive characteristics of a chart,

we can always: 1) consider several of the minor characteristics; 2) give a comprehensive delineation of one of the areas of life (most frequently love or work) which is the client's primary concern now; and 3) answer questions which were not answered during the initial interpretation.

Consider a color wheel. How vivid each color is when viewed separately, but spin the wheel and notice that as the speed increases, each individual color becomes less distinct. At high speed, all that can be seen is white. Only by stopping the color wheel and viewing each primary color one by one again can we experience and appreciate each shade and hue in all of its infinite richness. Similarly, only by paying attention to the 5-10 most distinctive characteristics of the chart, by studying and interpreting each of these in depth, and by relating them to each other, can we develop and communicate a clear picture of the natal chart rather than a whizzing blur of planets, signs and houses.

Consider now a newspaper article. A reporter presents the details of a story in descending order, the most important information first, then the next important, and finally the least important, so that it may be cut if there isn't enough space for the complete article in the paper. The reader may glance at the first sentence or two and distill the essence of the article; he/she is oriented from the very beginning. The rest of the article elaborates upon the first few sentences, filling in more information as it goes on, and does not for a moment lose the central focus, which gives all the details coherence and order.

If we want to give coherent readings, we can learn from the newspaper article. We must determine what is most important in the chart and what is least important. We must develop the ability to focus upon the essentials of the chart and allow the inessentials to be dealt with only when the most significant information has been presented as clearly and completely as possible. But unlike a news writer, we will dialogue with our audience; we will want to make sure that our clients under-

stand what we are saying. Therefore, we will explore each facet of the chart that we deem important in the utmost depth—imparting all that we know about that characteristic, astrologically and personally. We will listen to our clients and let them relate what we are saying to their own lives, so that they assimilate its meaning and ramifications in their own way and are able to distill a grain or two of wisdom from the exploration.

This book is primarily concerned with interpretating the most outstanding features of a chart. It is not a comprehensive manual on chart interpretation. It does not interpret the meanings of the planets in signs, houses or aspects, nor does it tell all there is to know about patterns, planets on angles, the phases of the Moon, etc. When only the bare essentials are presented, astrology texts will be recommended which deal with that particular topic in more depth.

The purpose of this book is to provide a valid and comprehensible method of synthesizing the natal chart. This method depends upon the use, at least initially, of a worksheet for determining the essential characteristics of a chart. In the beginning stages of chart interpretation, only a system, an organized method, can help us to create order out of chaos and to penetrate to the central issues of an individual's chart and personality. After we have used the worksheet five or six times, the process of synthesis will become quick and automatic, and the form itself will no longer be necessary.

What is the nature of this worksheet? Basically, it is a list of characteristics to look for as we first examine a chart. Not everything that many astrologers consider important is included on it; some traditional and modern techniques are emphasized, while others, which do not really seem to merit the attention paid to them, are ignored. But the worksheet, nonetheless, will enable us to list the 15 or 20 most important characteristics of any chart, and then to reduce these to the 5-8 which should most demand our attention. We can best prepare to give a reading by filling out the worksheet for a

chart, and then by spending 20-30 minutes reflecting upon the issues which we have determined are the most significant. The process of notetaking may be helpful in reaching a clear understanding of the chart and presenting it to our client in an intelligible manner.

The example section of this book includes several charts of famous people which we can use to practice our synthesizing abilities. They are also "guessing games" for us to play, for the charts are unidentified. In the section following the charts and worksheets, we will discover the identity of each chart, as well as the author's opinion of the central features of each one, and a sample interpretation.

The final portion of this book addresses the interactive dimensions of chart interpretation, which require some understanding of the counseling process, and awareness of the needs and feelings of the person whose chart we are interpreting. If we are concerned not merely with imparting information, but also with helping the other person to integrate and utilize the material we are presenting, then we need to assess our own interpreting and counseling process. It is important to learn to express our knowledge in a way which benefits another person, and to develop the skills necessary to facilitate his or her own growth process. We may not only want to present "what is" in terms of personality dynamics; we may also want to give constructive guidance and help our client or friend translate insight into action.

If there is any principle which we should keep in mind as we develop the art of chart synthesis, it is this: Start with the characteristics which are most extreme, most powerful, most outstanding, and let the rest of the chart interpretation take shape around them. Then we can be assured that although we may neglect to cover a wide variety of characteristics and issues when we are giving a reading, that we will not, by any means, neglect to cover those which are vital and which will continue to be vital throughout this person's life. By the end of the reading, our client will probably have deepened his/her

insight in regard to one or more of these issues and will have gained enough clarity of understanding that he/she will remember these issues, reflect upon them, and perhaps even develop the desire and resolution necessary to work with them and turn them all into advantages and accomplishments.

PRINCIPLES OF INTERPRETATION

1. We can express our planets, signs, houses and aspects positively or negatively. Whether they become *destructive* energies impeding our happiness and growth or *constructive* energies promoting our happiness and our growth depends not upon their placement in our natal charts but upon our willingness to develop our self-awareness and to exert the effort necessary to transform a negative into a positive.

 Our charts are not static or closed. We can direct our planetary energies rather than be directed by them. We can transform them by developing a center in ourselves — through meditation, self-observation, and astrological/psychological understanding, and by acting from that center, with full awareness of all facets of our personalities. People whose planets balance or stimulate ours in some needed way, as well as transits and progressions, can also open new possibilities within us and help us to unfold the potential of our charts.

2. An aspect between two planets is a pathway of energy. Whether it is a conjunction or opposition, a square or a trine, it can operate advantageously in our lives. Squares and oppositions present more problems than trines or sextiles, but they also provide the alchemical fuel, the motivation necessary for self-transformation. A conscious attempt to express a positive blend of the planets involved in a square or opposition aspect can eventually overcome the conflicts that the aspect may generate. However, we must be willing to experience an aspect's negative manifestations and learn from them, in order to move beyond the negative and experience the positive manifestations.

3. We create our own realities according to our beliefs and expectations. If we expect a planet to be malefic, it will be malefic. But to expect it to be benefic is not enough; we must also *use* it beneficially.

Probably the most important message I have for you who are reading this book, particularly those of you whose lives are troubled and whose charts are afflicted, is this: Your lives are in your own hands. Your charts, like your lives, are open-ended, and like magic circles, are capable of transformation. You have such immense possibilities, and whatever possibilities you follow, every experience, no matter how difficult, can be a source of growth, strength and fulfillment. You can turn your conflicts into joys, your squares into trines.

Astrology can help you to attune yourself to your inner vision. It can help you to discover ways in which you can translate that vision into concrete terms. But it is up to you, and it will always be up to you, to remain in touch with that vision, to follow it, and to live by its illumination.

reprinted from
The Directory of New England Astrologers,
edited by Tracy Marks

A PRELIMINARY NOTE

When calculating and interpreting a chart, the author recommends that you:

1. Use the Campanus house system rather than Placidus or Koch. Porphyry is also acceptable.

2. Consider planets in the last 3 degrees of a house to be influencing the next house.

3. Allow an 8-degree orb for conjunctions, squares, oppositions and trines, and a 4-degree orb for sextiles and inconjuncts, adding 2 degrees to the orb if the Sun or Moon is involved and 4 degrees for Sun/Moon aspects. These orbs may be increased slightly if the aspect is part of an aspect configuration, if planets are also in parallel or in mutual reception, or if they are *both* approaching each other (e.g., Jupiter 16 Leo retrograde square Mercury at 7 Taurus direct).

4. Consider the conjunction to be the strongest aspect, followed by the opposition, square, trine, sextile, inconjunct and semi-square.

5. Determine aspects to the ascendant and midheaven, allowing a 4-degree orb (6 for conjunctions).

6. Use a 14-point scale for counting elements and modes. See sections A 1-4. An acceptable alternative is a 12-point scale which gives ½ count to Uranus, Neptune, Pluto and the M.C.

7. Consider Saturn the ruler of Capricorn, Pluto of Scorpio, Mars of Aries and Jupiter of Sagittarius.

8. Draw colored lines across the chart to indicate aspects; these will help you to perceive the patterns operating in the chart. You might, for example, circle conjunctions in purple, and draw green lines for sextiles, blue for trines, red for squares and black for oppositions.

9. Set up your charts on an open wheel (see charts in practice
 section) rather than one bound by a closed circle. This will
 help you to remember that the horoscope is not a fixed
 diagram of the psyche, but is open to the influences of
 transits, progressions, the planets of the significant people
 in your life, and your own free will.

PART ONE

TECHNIQUES OF CHART SYNTHESIS & INTERPRETATION

SYNTHESIS WORKSHEET

©1979, 1985 by Tracy Marks

A. **THE CHART AS A WHOLE** (p. 23)

 1. PREDOMINANT ELEMENT (p. 23)
 How many? Circle if more than 5/14.

 2. WEAKEST ELEMENT (p. 25)
 How many? Circle if 0 or 1/14.

 3. PREDOMINANT MODE (p. 28)
 How many? Circle if more than 6/14.

 4. WEAKEST MODE (p. 30)
 How many? Circle if 0, 1/14 or 2/14.

 5. PLANETARY PATTERN (p. 31)
 Circle if pattern is clearly defined.

 6. ASPECT CONFIGURATIONS (p. 36)
 Circle answer.

 7. SUN/MOON SIGNS & RELATIONSHIP (p. 47)
 Note aspect or phase. Circle
 if in major aspect.

 8. ASCENDANT/MIDHEAVEN SIGNS (p. 53)
 Circle ascendant.

 9. NUMBER OF RETROGRADE PLANETS (p. 54)
 Circle if 0 or more than 3.

B. **DETERMINING PLANETARY STRENGTH** (p. 58)

 1. SUN SIGN & HOUSE (p. 58)
 Circle answer.

 2. MOON SIGN & HOUSE (p. 59)
 Circle answer.

B. **3.** SUN RULER: ITS SIGN & HOUSE (p. 60)

4. ASCENDANT RULER: ITS SIGN & HOUSE (p. 60)

5. PLANET IN OWN SIGN (p. 60)
Circle answer.

6. PLANET IN OWN HOUSE (p. 61)
Circle answer.

7. PLANET RISING (p. 61)
Circle if less than 2 degrees above
or 6 degrees below ascendant.

8. PLANET ON MIDHEAVEN (p. 62)
Circle if less than 2 degrees before
or 6 degrees after midheaven.

9. PLANET ON NADIR (p. 62)
Circle if less than 1 degree before
or 2 degrees after nadir.

10. PLANET DESCENDING (p. 63)
Circle if less than 1 degree before
or 2 degrees after descendant.

11. STATIONARY PLANET (p. 63)
Circle answer.

12. SOLE DISPOSITOR (p. 64)

13. MOST ASPECTED PLANET (p. 65)
How many aspects?

14. UNASPECTED PLANETS (p. 66)
Circle answer.

15. OTHER FOCAL PLANETS (p. 67)
Circle answer.

C. ASPECTS & OTHER CHART VARIABLES

1. PREDOMINANT TYPE OF ASPECT
(p. 68) How many?

2. ABSENCE OF A TYPE OF ASPECT
(p. 70)

3. CONJUNCTIONS WITHIN 3 DEGREES
(p. 71) Indicate orb. Circle if less than
$1\frac{1}{2}$ degrees.

**4. OTHER MAJOR ASPECTS WITHIN $1\frac{1}{2}$
DEGREES** (p. 71) Indicate orb. Circle
if less than 1 degree.

5. IMPORTANT MINOR ASPECTS (p. 72)
Note those which are exact.

6. PARALLELS REINFORCING ASPECTS
(p. 74)

7. MUTUAL RECEPTIONS (p. 75)
Circle answer.

8. LUNAR NODES (p. 76)
Indicate sign & house. Circle answer.
List major aspects within 2 degrees.

D. PRELIMINARY SYNTHESIS (p. 78)

1. STRONGEST PLANETS
How many counts?
Circle if more than 4.

2. STRONGEST SIGNS How many counts?
Circle if more than 4.

3. STRONGEST HOUSES How many counts?
Circle if more than 4.

D. **4.** STRONGEST ASPECT
Circle if less than 30 minutes.

E. ADDITIONAL CONSIDERATIONS (p. 80)

F. THE PRIMARY CHARACTERISTICS OF THIS CHART

1.

2.

3.

4.

5.

6.

7.

8.

*NOTE: Reader is advised to keep this worksheet blank for photocopying. This worksheet may be copied for personal use, but not for resale without permission from the publisher. Quantity discounts on this book are available to teachers in order to facilitate classroom use. Please note that there are 5 blank worksheets in Part Two for use with the sample charts.

1.

The Chart as a Whole

The first step in interpreting a chart involves considering the chart as a whole and assessing its overall patterns, as well as the balances or imbalances which exist among the primary astrological variables.

A1. PREDOMINANT ELEMENT
(How many? Circle the number if more than 5 out of 14 possible points.)

The fire signs are Aries, Leo and Sagittarius; the earth signs, Taurus, Virgo and Capricorn; the air signs, Gemini, Libra and Aquarius; and the water signs, Cancer, Scorpio and Pisces.

To determine the predominant element in any chart, add up the number of fire, earth, air and water signs which contain planets, as well as the signs of the ascendant and the midheaven. Using a 14-point scale, count the Sun and Moon signs as 2, the signs of the other planets as 1, and the signs of the ascendant and midheaven as 1. If a planet is between 29 degrees of one sign and 0 degrees of the next sign, it is under the influence of both, and its count should be divided between the two signs in question.

Consider the element count in a chart with the following planet and angle positions:

			FIRE	EARTH	AIR	WATER
Sun	2	Scorpio 20				2
Moon	29	Taurus 53		1	1	
Mercury	24	Libra 24			1	
Venus	9	Libra 47			1	
Mars	16	Scorpio 38				1
Jupiter	29	Capricorn 05		½	½	
Saturn	23	Capricorn 54		1		
Uranus	29	Leo 47	½	½		
Neptune	10	Scorpio 44				1
Pluto	9	Virgo 31		1		
Asc.	13	Gemini 31			1	
M.C.	19	Aquarius 27			1	
			½	4	5½	4

A well-balanced chart would have 3-4 counts each of fire, earth, air and water signs. Five counts of any element is an emphasis; six or more counts is an extreme emphasis. In the example given here, the predominant element air is moderately strong.

The following keywords should help you to interpret the emphasized elements in a chart. Insert "very" before each of these keywords when there are 5 counts of a particular element; insert "overly" if there are 6 or more counts.

FIRE		
enthusiastic	intense	self-confident
energetic	stimulating	independent
impulsive	inspirational	idealistic
spontaneous	creative	optimistic
ardent	self-motivated	subjective

People with 6 or more fire signs may also be dominating, fast-paced, and inclined to invest all of themselves into their activities. They may have difficulty perceiving other people as separate individuals, with their own valid needs and desires.

EARTH: *practical* *productive* *patient*

EARTH:		
practical	*productive*	*patient*
materialistic	*methodical*	*persistent*
down-to-earth	*exacting*	*enduring*
security-minded	*thorough*	*dependable*
realistic	*orderly*	*stable*

People with 6 or more earth signs will be concerned with concrete details and tangible results. They will operate most frequently in the world of their senses, attuned to their immediate environment, to their physical bodies, and to sensory comforts and pleasures.

AIR:		
intellectual	*observant*	*indecisive*
questioning	*objective*	*talkative*
conceptualizing	*detached*	*interacting*
synthesizing	*unrealistic*	*cooperating*

People with 6 or more air signs usually live in their minds, restlessly seeking knowledge and sharing their thoughts with other people. Somewhat impersonal, they nevertheless thrive on communication and social interaction.

WATER:		
moody	*responsive*	*personal*
sensitive	*dependent*	*flowing*
vulnerable	*nurturing*	*intuitive*
sentimental	*protective*	*imaginative*
empathic	*secretive*	*passive*

People with 6 or more water signs frequently lose themselves in their feelings or the feelings of other people, and have difficulty maintaining their separateness. Their extreme sensitivity often leads them to withdraw into themselves. Often quite psychic, they respond with great compassion to the needs of other people.

A2. WEAKEST ELEMENT
(How many? Circle if 0 or 1/14.)

If a chart has 0 or 1 of an element, or if all the counts of one element are those of outer planets, the individual in question may be markedly deficient in the characteristics of that

element. Two counts of an element indicates a minor deficiency. Sometimes, other variables in a chart can at least partially compensate for this deficiency.

Compensations for 0 or 1 fire counts include: Mars in a fire sign (particularly Aries); Mars in a focal position (conjunct an angle, at the end of a t-square or at the handle of a bucket); Mars in, or to some extent ruling a fire house (particularly the 1st house); Mars conjunct Sun, Jupiter or Moon; Jupiter in Sagittarius; or a cardinal emphasis.

Compensations for 0 or 1 earth counts include: Saturn in an earth sign (particularly Capricorn); a focal Saturn (conjunct an angle, at the end of a t-square or at the handle of a bucket); Saturn in, or to some extent ruling an earth house (particularly the 10th house); Saturn conjunct Sun, Mercury or Mars; Mercury in Virgo; Venus in Taurus; or an emphasis on fixed signs.

Compensations for 0 or 1 air include: Mercury in an air sign (particularly Gemini); a focal Mercury (conjunct an angle, at the end of a t-square or at the handle of a bucket); Mercury in, or to some extent ruling an air house (particularly the 3rd house); Mercury in Virgo; Mercury conjunct Sun; Uranus or Venus; Venus in Libra; or a mutable emphasis.

Compensations for 0 or 1 water include: Moon in, or to some extent ruling a water house (particularly the 4th house); a focal Moon (conjunct an angle, at the end of a t-square or at the handle of a bucket); Moon conjunct Sun, Neptune or Pluto; or an emphasis on mutable signs.

These compensations should be taken into account when assessing the importance of a particular deficiency in a chart. Such compensations may not substitute for a lack of an element; they may simply increase the desire to express that element, without giving the natural ability to function accordingly. Nevertheless, because people who are weak in an element have not developed most of that element's characteristics, they usually are aware of their lack and strive to overcome it. Initially, their attempts to compensate for an inherent lack

may make them appear as if the element in question is strong in their charts. However, because they usually "hunger" so deeply to function on this energy level, they may try too hard and create problems for themselves.

LACK OF	*pessimistic*	*uninvolved*	*unmotivated*
FIRE:	*apathetic*	*depressed*	*unexcitable*

Although they struggle to become self-expressive and assertive, these people alternate between withholding themselves and expressing themselves in an overly dramatic manner. They may become mired in a hectic schedule of impersonal activities or may, in contrast, become overly preoccupied with their personal experience. Because they are not often aware of or enthusiastic about new possibilities, they may look to others for inspiration and motivation. They often feel passive and detached or uninvolved; they seek deeper personal and emotional involvement in life.

LACK OF	*impractical*	*unproductive*	*security-conscious*
EARTH:	*disorganized*	*unstable*	*ungrounded*
	compulsive		

These people often develop skills which have no practical application, flit from job to job, or bounce checks and borrow money freely. Or, in contrast, they overemphasize the practical by becoming secretaries or accountants, or being overly particular about budgeting, everyday details, and order. Because they do not feel grounded, they frequently seek security by adhering to a highly structured system of thought or by following an organized but rigid routine. They may hold onto a job or relationship too long because of the stability and security it provides.

LACK OF	*subjective*	*disconnected*	*simple*
AIR:	*searching*	*isolated*	

These people often hunger for social interaction. Although very concerned with communication, they frequently feel out of contact or misunderstood; they may prefer to express them-

selves through non-verbal or written channels rather than the spoken word. Distrustful of the intellect, they learn primarily from experience. Nevertheless, they are endlessly conceptualizing and clarifying their thinking. Because they lack objectivity, they may gain understanding of themselves only through receiving feedback from other people.

LACK OF	*controlled*	*unresponsive*	*insecure*
WATER:	*closed*	*impersonal*	*out of touch*

These people frequently turn to spiritual realms or universal truths in an attempt to find meaning in their lives, or to fill the emotional vacuum which their personal relationships are unable to fill. Their difficulty remaining in touch with and expressing their feelings may lead them to form relationships with overly emotional people or to become addicted to excitement and intensity. Because they may not be aware of or able to respond empathically to other people's feelings, they may attempt to prove that they are sensitive by engaging in nurturing activities (such as cooking a meal) or by acting overly concerned or solicitous.

A3. PREDOMINANT MODE
(How many? Circle if more than 6.)

The modes or qualities, consisting of cardinal, fixed and mutable signs, are not as important as the elements, but do reveal significant personality characteristics. The cardinal signs are Aries, Cancer, Libra and Capricorn; the fixed signs, Taurus, Leo, Scorpio and Aquarius; and the mutable signs, Gemini, Virgo, Sagittarius and Pisces.

Using the 14-point scale, count the modes in a chart the same way you counted the elements. The example in section A1 yields 3½ cardinal, 7 fixed and 3½ mutable according to this system. Because 4–5 cardinal signs is average, 6 strong and 7 or more very strong, this chart has a very strong fixed emphasis.

The following keywords should help you to interpret the emphasized modes in a chart. Insert "very" before each of these keywords when there are 6 counts of a particular mode; insert "overly" when there are 7 or more counts. You will notice that in some ways cardinal signs are similar to fire signs, fixed to earth, and mutable to both air and water.

CARDINAL:	*active*	*energetic*	*ambitious*
	involved	*busy*	*opportunistic*
	restless	*driving*	

People with 7 or more cardinal signs would rather be overly active than bored. Although very concerned with their activities and projects, they also focus their attention on the crucial areas of life—home and family, love and profession, and are intent upon meeting challenges and resolving crises. Much depends upon whether Aries, Cancer, Libra or Capricorn dominates the chart.

FIXED:	*determined*	*stubborn*	*strong-willed*
	purposeful	*inflexible*	*slow & deliberate*
	persistent	*powerful*	

People with 7 or more fixed signs focus their attention on their values and goals, and the satisfaction of their desires. Slow to start, they are nevertheless powerhouses once they determine their course of action. They resist changing direction, and refuse to be pushed, pulled or pressured.

MUTABLE:	*adaptable*	*personal*	*weak-willed*
	versatile	*personable*	*indecisive*
	changeable	*flighty*	*easily influenced*
	variable	*restless*	*serving*

People with 7 or more mutable signs are concerned with personal relationships, and thrive on variety and change. More inclined to flow with the current than swim against the tide, they adapt themselves readily to the people and circumstances of their lives. Frequently, however, they do not know what they want or where they want to go.

A4. WEAKEST MODE
(How many? Circle if 0, 1 or 2.)

Because the average number of counts for a mode on the 14-point scale is 4 2/3, people rarely have 0 or even 1 of a cardinal, fixed or mutable sign. We would therefore consider a count of 0, 1 or 2 as a marked deficiency. As with elements, people who are very weak in a particular mode are usually aware of their lack and strive to overcome it. Often, too, they have built-in compensations in their charts. These compensations, however, may have to be very strong or very numerous to make up for an extreme deficiency.

Compensations for 0, 1 or 2 cardinal signs include: Mars in a cardinal sign (particularly Aries); a focal Mars (conjunct an angle, etc.); Mars in or (to some extent) ruling a cardinal (angular) house; Mars conjunct Sun, Moon or Saturn; Sun or Moon in Aries; Saturn in Capricorn; a predominance of fire signs; or a bucket pattern.

Compensations for 0, 1 or 2 fixed signs include: Sun in a fixed sign; Sun conjunct Pluto, Saturn, Uranus, the ascendant or the midheaven; Sun in or, to some extent, ruling a fixed (succedent) house; a predominance of earth signs; or a locomotive pattern.

Compensations for 0, 1 or 2 mutable signs include: Mercury in a mutable sign (particularly Gemini or Virgo); a focal Mercury (conjunct an angle, etc.); Mercury in or, to some extent, ruling a mutable (cadent) house; Mercury conjunct Sun, Moon, Jupiter or Neptune; a predominance of air or water signs; or a splash pattern.

The following keywords can be used as a guide in interpreting the lack of a mode in a chart:

LACK OF CARDINAL: These people can easily enjoy observing and simply "being" without necessarily "doing." But if they have 0 or only 1 cardinal sign, they may feel driven to prove themselves through activity or may sub-

stitute an emotionally intense inner life for active involvement in external challenges.

LACK OF FIXED: These people may have difficulty completing what they have begun and developing structure and stability in their lifestyles. They may, as a result, become obsessed with organizing or finishing, and may test their willpower by committing themselves to overly-demanding projects or goals.

LACK OF MUTABLE: These people usually know what they want. Frequently unwilling to compromise, they may insist that other people be adaptable and accommodate them. Because they have difficulty bending with circumstances and making personal changes, they often attempt to force change in their external circumstances, sometimes in dramatic ways.

A5. PLANETARY PATTERN
(Circle if pattern is clearly defined.)

Not all charts have planetary patterns, and fewer still have clearly defined patterns. If the pattern of a chart is not obvious, the pattern is not likely to be as important in interpretation as the other predominant characteristics of the chart.

The following definitions and interpretations are sketchy ones. For more information, the reader may want to consult Marc Edmund Jones' *Guide to Horoscope Interpretation*, Dane Rudhyar's *First Steps in the Study of a Birthchart* (published as a small book and also as a portion of *Person-Centered Astrology*) and especially Robert Jansky's *Planetary Patterns*, which not only includes most of the information contained within the preceding books, but also supplements it with Jansky's recent discoveries.

SPLASH PATTERN

DEFINITION—Planets are scattered around the chart, usually with no more than two planets in any one house, with no more than three empty houses, and with no empty area larger than two houses or 60 degrees.

INTERPRETATION—The splash personality is quite Gemini-like, with a variety of interests and abilities and a tendency to scatter his/her energies rather than focus upon one or two particular areas of life.

BOWL OR HEMISPHERE PATTERN

DEFINITION—All planets fall within 180 degrees (or a maximum of 190 degrees) and on one side of an opposition, and no more than 60 degrees or two houses of the occupied portion of the chart are empty.

INTERPRETATION—The bowl personality can function in a self-contained manner in the houses occupied by planets, but usually focuses upon achieving in the unoccupied area (particularly in the sign and house which opposes the midpoint of the bowl). The first planet of the bowl (the first to have crossed the ascendant, moving clockwise) indicates the energies most frequently used to fulfill his/her needs.

BUCKET OR FUNNEL PATTERN

DEFINITION—The bucket is a bowl pattern with a handle, the handle being a planet or two closely conjunct planets at least 30 degrees from the planets within the bowl (but preferably closer to 90 degrees away from them and opposing a planet near the center of the bowl).

INTERPRETATION—The bucket personality channels his/her energy through the handle of the bucket. The sign and house position of this singleton or focal planet usually indicates the kind of energy this person most frequently expresses and the area of life through which he/she seeks satisfaction.

LOCOMOTIVE OR OPEN-ANGLE PATTERN

DEFINITION—All planets fall within 240 degrees (or a maximum of 250 degrees), with no more than two houses or 60 degrees empty within the occupied area, and with a trine bridging the unoccupied area.

INTERPRETATION—The locomotive personality is an energetic, self-driving, determined individual who single-mindedly focuses upon achieving his/her purpose, which is generally indicated by the midpoint of the empty trine. The first planet (the first to have crossed the ascendant, moving clockwise) is the engine; its sign and house position indicates the energy which fuels his/her drive to incorporate the midpoint of the empty trine into his life.

SEESAW OR HOURGLASS PATTERN

DEFINITION—Planets are divided into two groups, at least 60 degrees or two empty houses apart, with no more than one empty house within each group, and with at least one opposition.

INTERPRETATION—The seesaw personality is quite Libralike—concerned with relationships, aware of alternatives, fluctuating between different parts of himself, and attempting to maintain balance through his/her ability to synthesize and compromise.

BUNDLE, CLUSTER OR WEDGE PATTERN

DEFINITION—All planets are contained within a trine—120 degrees, or with orb allowances, a maximum of 130 degrees.

INTERPRETATION—The bundle personality is a self-contained, focused personality who resourcefully concentrates his/her energy upon a limited area of life, indicated by the signs and houses occupied by planets. This individual has little perspective, but has the capacity to develop his/her resources to the utmost. The first planet often indicates energy which may be used to achieve in the area of life indicated by the far midpoint of the bundle.

PLANETARY PATTERNS

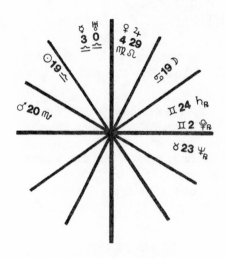

Eleanor Roosevelt
bowl pattern

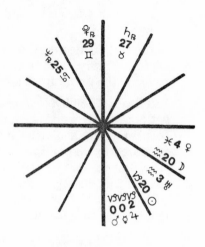

Richard Nixon
seesaw pattern

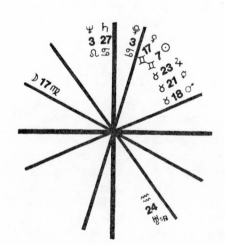

John Kennedy
fan pattern

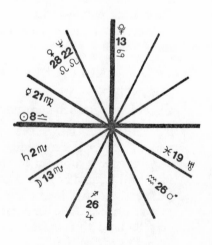

Jimmy Carter
locomotive pattern

PLANETARY PATTERNS

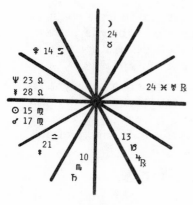

Peter Sellers
splash pattern

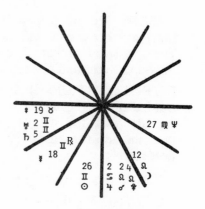

Paul McCartney
bundle pattern

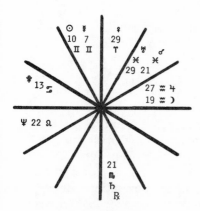

Marilyn Monroe
bucket pattern

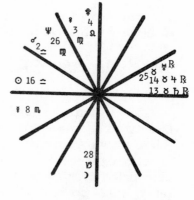

John Lennon
splay pattern

FAN PATTERN

DEFINITION—All planets but one (or two in close conjunction) are contained within the trine of a bundle pattern. This singleton or handle is at least 60 degrees apart from the bundle area and opposes at least one of its planets.

INTERPRETATION—Rather than directing one's energy outward through the handle as in a bucket pattern, the fan personality uses the handle planet as a source of support or nourishment, through which he/she takes in to satisfy his/her needs.

SPLAY OR TRIPOD PATTERN

DEFINITION—Planets are divided into three groups, with each group at least 60 degrees or two houses apart from another group. In its purest form, these groups cover no more than 60 degrees each and are connected by a grand trine.

INTERPRETATION—The splay personality is generally a unique individual who self-assuredly follows his/her own path. The presence of a grand trine adds predictability and self-sufficiency in fire, earth, air or water characteristics.

A6. ASPECT CONFIGURATIONS
(Circle answer.)

Aspect configurations are even more important than planetary patterns and deserve at least a book in themselves. Bill Tierney's *Dynamics of Aspect Analysis: New Perceptions in Astrology** covers them sufficiently and explores their potentials for aiding growth and self-transformation. Robert Jansky's *Interpretating the Aspects* is also an excellent source on aspect configurations. The major aspect configurations are: the stellium, the grand trine, the t-square, the grand cross, and the yod or "finger of God."

*Available from CRCS Publications; see address on title page.

THE STELLIUM

DEFINITION—Traditionally, a stellium must involve at least four planets (or at least five planets if the Sun, Mercury and Venus are included) with each planet within 8 degrees of the next, and all within the same sign. The meaning of the stellium, however, holds true for any four planets, even if three are interior planets or if all are within the same house rather than the same sign. Other configurations will function like a stellium but with not quite the same intensity when three rather than four planets are in close conjunction; four planets are in conjunction but not within the same sign or house; orbs between two of the planets are slightly greater than eight degrees; or three planets conjunct a node or angle of the chart. A stellium is particularly strong if more than four planets are involved within it, or if one is the Sun or Moon or a planet in its own sign or house.

INTERPRETATION—Positive characteristics of the stellium include: concentrated energy, focus, genius, talent, self-motivation, sense of direction and purpose, and singlemindedness. Negative characteristics include: narrowness, obsession, overemphasis, imbalance, self-centeredness, difficulty compromising, and lack of objectivity. Planets in a stellium normally act as a unit, giving extraordinary emphasis to the sign and/or house in which they are placed. The meaning of the sign/house combination should be interpreted before the individual conjunctions contained within the stellium.

Consider the stellium to be like a close family. If the father loses his job, everyone in the family is affected. If a daughter wins an award in school, everyone experiences her happiness. In a stellium, those planets which are closest will most affect each other, but even those which are more distant will experience the repercussions. Usually, the planet in the middle or closest to the midpoint of the stellium will be the most sensitive to the influences of the other planets.

Aspects the stellium makes to other planets or to the angles of the chart will indicate how the stellium functions in

relation to other energies in the chart. Because transits and progressions create a chain reaction which triggers all the planets within the stellium, people with stelliums will experience periods of calm in their lives alternating with periods of intense upheaval and change.

THE GRAND TRINE

DEFINITION—The grand trine involves three planets, usually in the same element, in trine to each other—the first trine the second, the second trine the third, and the third trine the first. A grand trine is strong if it involves more than three planets in the same element and weak if it involves more than one element.

INTERPRETATION—Positive characteristics of a grand trine include: free energy flow, luck, ease in obtaining benefits and opportunities, self-motivation, self-sufficiency and talent—all related to one particular element. Negative characteristics include: laziness, inertia, escapism or avoidance of challenge, "moving in circles," bound by habits or past patterns of behavior, closed, distant, living in "one's own world."

Grand trines have been best described by Noel Tyl, who refers to them as "closed circuits of self-sufficiency." People with grand trines are motivated, independent and talented when functioning on the level of the element emphasized by their grand trine, but tend to "get stuck" or to retreat into that one part of themselves. People with a grand fire trine will have ceaseless energy and vitality but will have difficulty slowing down, understanding another person's point of view, or channelling energy in response to another person's needs. People with a grand air trine may be intellectually and socially a world to themselves, able to provide their own mental stimulation, but often unable to turn off the mind and deal directly with emotional or practical issues. People with a grand earth trine will be able to apply themselves successfully to a job and will easily attract and manage material resources, but may become bound by ambition or mundane concerns and closed

ASPECT CONFIGURATIONS

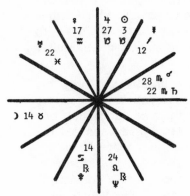

Carlos Castaneda
Fixed Grand Cross
Grand Water Trine

Bobby Fischer
T-Square to Moon
Grand Air Trine

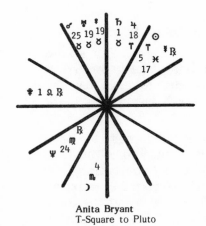

Anita Bryant
T-Square to Pluto

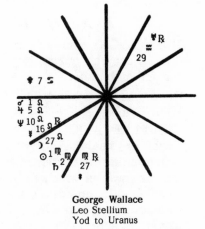

George Wallace
Leo Stellium
Yod to Uranus

to other sources of meaning in life. People with a grand water trine will have an active emotional life and a high degree of sensitivity, but may be unable to share their feelings with other people or rise above their feelings and view themselves objectively.

When interpreting a grand trine, consider not only the element which the grand trine accentuates, but also the nature of the planets and houses involved in the configuration. If one planet in the grand trine is also a pivotal planet, linking the grand trine to another aspect configuration, that planet will be the key to effectively expressing the talents of both configurations. The closest square or opposition to a grand trine is also important, for it is the spark of motivation which aids a person in applying his/her fire, earth, air or water talents to other areas of life. A grand trine with an opposition to one of its planets is called a kite formation; the opposing planet can lead to increased awareness and is a powerful channel for the expression of grand trine energies.

THE YOD OR FINGER OF GOD

DEFINITION—The yod consists of two planets in sextile, each inconjunct (150 degrees) a third planet, located at the far midpoint of the sextile. No orbs are more than five degrees. The planet which receives both inconjuncts is the focal or action planet.

INTERPRETATION—The yod configuration calls for emotional or mental readjustment and regeneration. The focal planet indicates the energies which must be regenerated; its sign, the way in which they need to be corrected or re-experienced; and its house, the area of life through which this transformation will take place. The focal planet is a very sensitive planet because its inconjuncts (6th and 8th house aspects) create a subliminal tension which can result in physical or psychological problems. This planet has been referred to as the mission in life, the finger of God, the finger of fate, the ultimate destiny, and the celestial pointer. Its negative manifesta-

tions must be cast out, as one casts out devils, and its highest expression activated. As the far midpoint of the sextile, it is the mediator which can use the dynamic creative energy and opportunity presented by the sextile to bring about a new way of being; it is the point of transmutation in the chart, the alchemical agent which can create an entirely new pattern of thinking and feeling.

People with yods generally experience turning points in their lives in which they confront a crisis and resolve it through a change in consciousness, often experienced as a seemingly fated change in life direction. This transformation at its best leads to increased spiritual sensitivity and awareness, the flowing of new energies, the building of an inner center, and the discovery of a concrete means for expressing one's creativity. Yods with a planet at the near midpoint of the sextile (30 degrees from each planet in sextile) are called tetradic yods, and especially call for a transformation leading to concrete action and the practical expression of creativity.

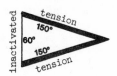

THE T-SQUARE

DEFINITION—A t-square involves three or more planets, with at least two in opposition and squaring a third planet. All three planets generally are within the same mode—cardinal, fixed or mutable, and no orbs should be over 10 degrees. A t-square is particularly strong if it involves more than three planets, if all planets are within a tight orb (less than 4 degrees), if one of its squares is exact (less than 1 degree), or if the focal planet, the planet receiving both squares, is at the midpoint of the two opposing planets. It is weak if planets

are in signs of different modes, if all orbs are over 6 degrees, or if a planet occurs in the sign opposite the sign of the focal planet. (This configuration may operate more like a grand cross.) When a planet squares the nodal axis or one of the main angles of a chart, a configuration is created which functions in the manner of a weak t-square.

INTERPRETATION—A t-square provides a high degree of motivation and the ability to achieve, but it may also result in wasted energy or energy expressed in an unfavorable manner, because the t-square individual is out of balance. He or she is inclined to lean too much in one direction (like a three-legged table), overdoing the expression of the focal planet, its sign and house, and then seeking balance by leaning too heavily in the opposite direction. But because it involves two squares as well as one opposition, the t-square requires activity as well as balance. It is the most common configuration in the charts of successful people; the focal planet is the key to the talent or accomplishment as well as the key to the source of frustration, neurosis or overcompensation.

In interpreting the t-square, all of the following are important:

1) The focal planet, its placement by sign, house and aspect, as well as the house or houses it rules in the natal chart. (These houses will also experience the tension and motivation of the t-square.) The focal planet may well be the most dominant planet in the chart, and the source of a large percentage of an individual's energy. *It must be used, and used wisely.* The secret of using the t-square effectively is to learn to express the focal planet in a positive manner, rather than be driven by its tension to compulsive activity, excess and overcompensation.

2) The nature of the opposition and squares, by planet and house. The closest of these aspects is a key to the primary source of conflict as well as the means for resolving that conflict.

3) The empty space—the degree, sign and house opposite the focal planet. If there are two focal planets in conjunction, the empty degree will be their far midpoint. The empty area needs to be consciously developed in a positive manner, so that the t-square individual does not need to overcompensate for inadequacy here by blindly throwing more undirected energy into the focal planet. The person must also learn not to retreat from the tensions of the focal planet by reverting to the most negative manifestations of the empty space. The Sabian Symbol for the degree of the empty space is often a key to the quality that needs to be developed; the placement of the ruler of the sign of the empty space is frequently a key to how that quality may most easily be expressed.

The three kinds of t-squares are cardinal, fixed and mutable t-squares. People with cardinal t-squares are the most active and the most inclined to plunge into crises related to their personal activities, home and family life, love relationships, or professional commitments. Often Aries-like, unless the t-square is to Libra, they need to cultivate the positive Libran qualities—balance, moderation, awareness of other people, perspective, and the ability to evaluate and compromise.

People with fixed t-squares display considerable strength of will, concentrated power and determination, particularly in regard to satisfying their own desires; they build up their energy slowly and then release it in a powerful manner, like a truck climbing a steep hill and then speeding down the other side. They usually need to discover constructive outlets for their intense energy and to develop a sense of values which includes sensitivity to other people's desires and needs.

People with mutable t-squares are usually over-adaptable, changeable, restless, versatile, and very much concerned with and influenced by personal relationships. Like a team of water skiers in formation, they need to cultivate balance in relationship to other people, often by discovering a sense of purpose

or mission which centers them and keeps them from being pulled in too many directions.

The meaning of a t-square is altered considerably if the focal planet is retrograde (a rare occurrence) or has turned retrograde by progression; this planet will operate less overtly than a direct planet and will influence the emotional, mental and physical well-being more than it will influence outward behavior. For more information on t-squares, see *Planetary Aspects: From Conflict to Cooperation** by Tracy Marks, available from Sagittarius Rising and CRCS Publications.

THE GRAND CROSS (OR COSMIC CROSS)

DEFINITION—The grand cross consists of at least four planets, four squares and two oppositions. The first planet squares the second, the second squares the third, the third squares the fourth, and the fourth squares the first; oppositions link the first and third planets as well as the second and fourth planets. Generally, all planets are in signs of the same mode, and orbs do not exceed 10 degrees.

Weaker variations of the grand cross involve planets in a combination of two modes (such as cardinal and mutable) or one planet slightly out of orb (10–12 degrees). Configurations which are created by an opposition in square to the nodes, ascendant/descendant axis or the midheaven/nadir axis may function somewhat in the manner of weak grand cross.

INTERPRETATION—Positive characteristics of a grand cross include inner power and strength, determination, the will to fulfill a purpose, productivity, concentration and channelling of diverse energies. There may also be an ability to integrate

*Ed. Note: Formerly entitled *How to Handle Your T-Square*, this book is the most thorough treatment of this configuration available. It covers not only the t-square configuration in natal charts, but also this pattern formed by transiting and progressed planets.

all dimensions of one's experience and translate ideals and values into concrete form. Negative characteristics include stagnation, inertia, scattering of energies, tremendous inner tension, resignation, the Atlas syndrome (carrying the weight of the world) and self-defeating behavior.

People with grand crosses generally feel pulled in four directions, and overburdened by the demands which they, as well as other people, place upon their time and energy. They live as if trapped in a room with four locked doors, and frequently try to force each door open by pounding upon it until they have exhausted themselves. Yet their situation is not hopeless, for if they position themselves in the middle of the room, they will discover a central staircase which will lead them to the roof and open air.

These people often feel stuck, paralyzed by the problems in their lives which seem to be unresolvable, until they turn inward and discover their own inner center. Then they are able to attain a spiritual or creative state of consciousness which allows them to rise above their mundane conflicts and view their life with clarity and objectivity. They need to examine the polarities in their lives, integrating and synthesizing seemingly contradictory facets of their experience (signified by the planets, signs and houses which oppose each other) around a purpose or goal which takes all parts of themselves into consideration. They need to concentrate their energy and direct it outward to fulfill the goal they have chosen. Evaluation, concentration, integration and application are the lessons to be learned from the grand cross.

from scatteredness to centeredness to centered action

When interpreting a grand cross, pay attention to the nature of the planets involved, their mode, and the houses in which they are placed in the chart. The opposition or square with the smallest orb will be a key to the most pressing problem in regard to awareness or action, and it must be resolved if energies are to be collected and focused effectively. Look also to the closest trine or sextile to planets in the cross, for the planet making the trine or sextile (and sometimes even a quintile) will be important in helping the individual to clarify his/her life situation and find a meaningful channel for his/her scattered energy.

The difficulties presented by a cross are related to the mode in which it occurs; the resolutions of its conflicts must be through that particular mode, which indicates a person's talents as well as his/her problems. People with a cardinal cross need to involve themselves in activities of personal importance, but because they are over-doers and may scatter themselves in too many directions in a frantic manner, they have to learn to focus their energies before plunging into action. People with a fixed cross slowly build up a high degree of inner tension, due to frustrated needs and desires, and then powerfully explode into forceful and sometimes destructive action; they are strong-willed, stubborn and can be extremely productive, provided that they find outlets through which they can constructively release their pent-up energy. People with a mutable cross are likely to be so easily influenced by their relationships and external circumstances that they tend, like a chameleon, to alter themselves to suit their changing environment; they need to define their identity—their needs, desires, goals, and to act in a manner that is true to themselves while maintaining a satisfying network of personal relationships.

A7. SUN/MOON SIGNS & RELATIONSHIP
(Note aspect or phase. Circle if in major aspect.)
For additional interpretation of the role of the
Sun and Moon in the chart, see section B1.

Because the Sun/Moon relationship symbolizes the relationship between our parents and the messages which we have internalized from them about our own role as male or female and about the opposite sex, it indicates the ease or difficulty we experience in human relationships. It also denotes to a large extent the degree of harmony which we experience with ourselves, and how our conscious sense of ourselves, our egos, operate in relation to our emotional and instinctive natures.

A major aspect between the Sun and Moon creates a powerful energy flow between consciousness and feelings/habit patterns; however, if no major aspect occurs (and orbs may be extended to as much as 12 degrees), the interplay between the Sun and Moon sign, as well as the Sun and Moon house, will still be a key to one's internal dynamics.

The relationship between the Sun and Moon can be summarized as follows:

SUN	MOON
the father and father principle; the role of men in our lives	the mother and mother principle; the role of women in our lives
ego; conscious sense of our identity; "I am"	instincts and feelings; awareness of emotions; "I feel"
self-sufficiency	emotional needs and dependency
self-confidence; pride; centeredness; inner power	emotional insecurity; moodiness; fluctuations
urge for control over ourselves and our environment; strength of will	tendency to adapt ourselves to our environment; passivity
self-centeredness; the drive for personal satisfaction	responsiveness to others; the need to nurture

SUN	MOON
the drive to fulfill a purpose	the urge to satisfy basic needs
how we integrate our experience into a unity of perception	how we instinctively react to our experience and flow with our habits and moods
our degree of consciousness of ourselves	degree to which we are unconscious of ourselves
how we focus in the present moment	the role of our past experience and behavior in our lives

When interpreting Sun/Moon aspects, remember that out-of-sign aspects (such as 28 Gemini square 1 Libra) weaken the meaning of the aspect in question, and that applying aspects (the faster planet approaching the degree of the slower planet) are stronger than separating ones. The major Sun/Moon aspects are as follows:

Sun conjunct Moon (New Moon): New Moon personalities are usually self-contained, self-absorbed and self-accepting individuals with a firm sense of their own identity and considerable inner power. Capable of concentrating their energy and directing their own lives, these people can act instinctively and spontaneously with little conflict between their conscious will and their emotional responses. Aware of their feelings and at ease with them, they are often a world unto themselves; their subjectivity may make it difficult for them to develop perspective or to perceive other people's experiences to be as real as their own. Frequently, they focus their attention upon a narrow sphere of interest, either their home and family life, or the area of life signified by the house in which the Sun/Moon conjunction occurs in their charts. These people usually experience their mothers and fathers as an undifferentiated unity—so close or so similar in role or personality traits that they together impart clear and consistent messages to their New Moon children.

People who have a Sun/Moon conjunction but were born slightly before the New Moon (i.e., their Sun is ahead of their

Moon by degree) are what Dane Rudhyar terms "balsamic types." Often, they are aware of a personal destiny or mission and sacrifice themselves to a purpose which they perceive as larger than themselves.

Sun square Moon (First Quarter or Last Quarter Moon): These people experience a high degree of inner tension because their sense of identity and their will are out of harmony with their feelings, instincts and habit patterns. They have difficulty acknowledging and accepting their feelings; they react to their environment in ways which prevent them from satisfying their desires; and they orient themselves toward goals which, when achieved, are not emotionally satisfying. Although the enormous amount of stress which they experience throughout their lives may result in digestive problems or other internal illnesses, they nevertheless know that inner tension is also a potent source of motivation. Few people struggle as relentlessly as Sun square Moon people do to find fulfillment in their activities and to prove to themselves that they are capable of surmounting all obstacles standing in the way of their happiness.

People who have a Sun/Moon square in their charts experience many contradictions within themselves because they have internalized contradictory patterns of behavior from parents who were in conflict with each other and whose marital difficulties may have led to divorce. As a result, they have no models for developing satisfying relationships themselves. Because they probably identified with one parent and harbored resentment against the other, they enter into adult relationships with negative expectations and may unconsciously provoke the very conflicts which they were intending to avoid. But although their love life and family life are rarely easy, these people do have the energy necessary to work out their interpersonal conflicts. As long as they persevere, find constructive outlets for their frustrated energy, listen to their feelings and integrate them with their conscious perceptions of themselves and learn from their mistakes, they may eventu-

ally by able to establish relationships which neither threaten their egos nor deny themselves the intimacy which they so deeply desire.

Sun sextile or trine Moon: People with a trine or sextile linking their Sun and Moon are internally consistent and self-accepting. They know what satisfies them, and their emotional energy and habit patterns aid them in fulfilling their desires. These people generally have little difficulty remaining in touch with their feelings and expressing them in a free-flowing manner; their vitality is high and they frequently possess creative talents. Usually well-adjusted, they are able to maintain a strong sense of their identity and meet their needs, while at the same time adapting themselves to their environment.

Usually, these Sun/Moon types experience their parents' relationship as harmonious. Able to establish comfortable relationships with both of their parents, they very early develop an ease in personal interactions which helps them, as adults, to maintain loving relationships. Being a part of a family is important to them, and they usually want to develop a family life for themselves which provides them with the same emotional sustenance they experienced in childhood.

The presence of Sun trine or sextile Moon in any chart can mitigate the conflicts generated by difficult squares and oppositions. The major problem of this aspect is that these people may make peace with themselves too easily. Rarely turning inward to explore their own psychological make-up and to develop self-awareness, they may drift through their lives displaying the same comfortable behavior patterns—patterns which neither further their growth nor provide the deep satisfaction of having successfully confronted personal challenges.

Sun opposition Moon (Full Moon): Full Moon people, like first or last quarter types, are at odds with their instinctual and emotional natures. The tension which they experience, however, needs to be worked out through personal relationships as well as through a change in consciousness, rather than through energetic activity.

These people generally experience a low vitality alternating with extremes of energy and feeling which keep them in a state of constant oscillation; as a result, they seek balance and moderation in their lives, and feel compelled to compromise, both in regard to their ambivalent feelings and desires, and in regard to their relationships. Aware of the division in themselves, experiencing it as a simultaneous pull in two directions or as a conflict between what they want to be and what they think they should be, they often feel alienated from their own internal source of energy and from the people around them. When they attempt to fulfill the desires of their Sun, they discover that the instinctual responses of the Moon are the polar opposite of their conscious aim. When they attempt to satisfy the needs of their Moon, their Sun (their ego), is threatened, and has difficulty accepting these needs as valid because they do not accord with the conscious sense of identity and self-esteem. The tension from this inner polarity can deplete their vital energy, but it can also lead to objectivity, to an awareness of the ambiguities and alternative ways of being which will eventually help them learn to synthesize their Sun/Moon qualities and to develop their own unique means of expressing both in an integrated and harmonious manner.

An effective synthesis of Sun opposition Moon generally occurs after these people have confronted the vacuum they experience in their lives and have mobilized their energy to find some form of meaning which transcends their mundane conflicts. Frequently, the intensity of their quest generates peak experiences, which may be accompanied by a vision or a fated sense of mission in life. Afterwards, they may choose to dedicate themselves to an ideal which their "revelations" have suffused with value, and they may attempt to manifest that ideal outwardly in their lives.

Full Moon people usually were raised in families in which the parents were either separated or were extremely opposite in personalities, complementing each other, but sharing little

in common. As a result, these people internalized dramatically different patterns of behavior; often, they identified with one of these patterns and began to attract people into their lives who expressed the other pattern. This tendency generally means that full moon types project part of their own psychological polarity onto other people; they feel at odds with other people until they begin to acknowledge the qualities they are projecting and develop an effective synthesis between their Sun and Moon. Relationships in which this projection occurs will bring them into contact with the parts of themselves which they have disowned and can help them to re-own those parts and end the unsatisfying drama they repeatedly enact with other people.

Other Sun/Moon Combinations: If the Sun and Moon in a chart are not in major aspect, a minor aspect may exist between them which describes their relationship. If no minor aspect exists, a planet aspecting both the Sun and Moon may be an intermediary between the conscious ego and the semiconscious emotional and instinctual patterns. People who have neither a major or minor aspect nor an intermediary planet between their Sun and Moon may experience more difficulty consciously accepting and integrating their emotional needs and habit patterns than people who have Sun/Moon squares and oppositions. Transits and progressions aspecting their Sun and Moon will usually help them to integrate and fulfill the needs of both parts of their personality.

The Sun/Moon relationship in a chart can be interpreted according to its aspect and also according to its phase in the Sun/Moon cycle. The most powerful of the aspects and phases coincide in meaning; they have been discussed on the preceding pages. The astrology student who is interested in exploring the meanings of other phases of the Sun/Moon relationship should consult Dane Rudhyar's *The Lunation Cycle*, or Busteed, Tiffany and Wergin's *Phases of the Moon*. Most of the information provided in these books is valuable, but is not essential to understanding the primary characteristics of the chart.

A8. ASCENDANT/MIDHEAVEN
(Circle ascendant.)

The sign of the ascendant, as well as the sign of its ruler and the nature of any planet rising in the chart, indicates external appearance—the physical body, dress and mannerisms. All the planets of the chart express themselves through the filter of the ascending sign, for it is the point at which all the energies of the chart surface and are revealed to other people. Frequently, we express the traditional meaning of our ascendant most of our lives, but we *aspire* to the higher meanings of the sign, which indicate the way in which we seek to develop ourselves and the ultimate purpose we attempt to fulfill through using the energies of our Sun, Moon and other planets.

The Sabian symbol for the degree of our ascendant is usually a personally meaningful image, evoking in us the aspirations which our ascending sign indicates. Consulting the Sabian symbols for the degrees before and after our ascending degree may be an aid in rectifying our charts and determining whether our given birth time is accurate.

The midheaven of our chart indicates the nature of the profession in which we are most likely to experience fulfillment, as well as our desire for achievement, success and status. It denotes the influence of our father (or most public parent) or any other authority figure in our lives. How we relate to society at large, how we seek to be recognized or to "belong," and how we orient ourselves toward concrete goals and bring about our success or failure in the public sphere are all described by the sign of our midheaven and the location of its ruler by sign, house and aspect. The midheaven is our public or professional aspirations rather than our personal and interpersonal (one-to-one) aspirations. Frequently here, too, the Sabian symbol for its degree is a key to its manifestation in our lives.

A9. NUMBER OF RETROGRADE PLANETS
(Circle if 0 or more than 3.)

Retrograde planets are functions of the personality which operate in an inward, indirect, subconscious and delayed manner. They generally indicate energies which we were not encouraged to express outwardly when we were young, and which, as a result, we must develop for ourselves, in our own way and in our own time. Most people have two or three retrograde planets; zero, one or four retrogrades is unusual but not extraordinary. People who have no retrogrades develop most of the important life skills at an early age and rarely need to explore their own psychological process until one of their planets turns retrograde by progression. People with four or more retrograde planets usually feel alienated from society and struggle more than most people to find their "niche" in the world. Turning inward when very young, they experience a need to define for themselves their own unique value system, philosophy or aim in life. Complex, reflective and individualistic, these people usually have to set their own standards and forge their own paths, even if doing so means eccentricity or isolation.

Regression, inhibition and withdrawal may characterize retrograde planets, but they also have considerable constructive potential in regard to self-understanding, self-directed activity and openness to unconscious and superconscious energies. Students familiar with secondary progressions should note whether retrograde planets in the natal chart have turned direct by progression, or direct planets have turned retrograde, because such changes will have a significant impact upon the personality.

Keywords for each of the retrograde planets are as follows:

MERCURY *contemplative, inner-directed mind*
RETROGRADE: *self-analytical and self-critical*
 awareness of psychological subtleties
 absentminded, not attuned to external details

MERCURY **RETROGRADE** continued:	*literary interests or abilities* *learns through absorption* *self-conscious speech or communication* *enjoys own company, not inclined toward small talk* *or casual interactions* *difficulty translating perceptions into words and* *making contact* *feels misunderstood or disconnected from others*
VENUS **RETROGRADE:**	*develops own unique social and aesthetic values* *undemonstrative, difficulty communicating affection* *self-loving, narcissistic* *fearful of intimacy and love* *seeking the perfect love, unrealistic ideals* *continually developing own value system* *ill at ease socially, reclusive, unwilling to play social* *games* *aesthetic sensitivity and talent* *nonmaterialistic* *tends to form unconventional relationships*
MARS **RETROGRADE:**	*inhibited action, lack of outer initiative* *noncompetitive, competing only with self* *explorer of the psyche, internally directed* *solitary or unconventional action* *repressed or explosive anger, passive-aggressive* *self-destructive, continually battling self* *tends to invite aggression* *doubts own capabilities, fears risk-taking* *alternately self-driving and lethargic* *sexual inhibitions or compulsions*
JUPITER **RETROGRADE:**	*highly philosophical and meditative* *psychologically attuned and insightful* *outwardly withholding but inwardly expansive* *attuned to inner meanings and purpose, self-guiding* *nonmaterialistic, seeks inner wealth* *develops own attitudes and belief systems* *alternately overly optimistic or pessimistic* *inward expansion, weight gain or incorporating* *tendencies* *socially reclusive, prefers one's own company* *rejects conventional and parental belief systems*

SATURN RETROGRADE:
inner stamina and endurance
resistance to personal change, rigidity
overly self-controlled and self-denying
demanding of self, repeatedly tests and "beats" oneself
self-doubting and self-critical, feels inferior
inclined to negativity or depression
unambitious, doubts own capacity for success, fearful
prefers to work alone, solitary
considerable self-motivation and perseverance
difficulty coping with authority, weak father figure
alternately overly defended or undefended

URANUS RETROGRADE:
outwardly conventional but inwardly unconventional
experiences alienation from society
psychologically minded, progressive thinking
inwardly rebellious, tends to rebel against self
highly developed intuition, original and inventive
capable of following inner direction
needs internal freedom to follow own path
nervous tension, high level of internal excitation
makes unexpected changes for the sake of change

NEPTUNE RETROGRADE:
vivid imagination, creative inclinations
difficulty translating inspiration into action
lives in a dream world, escapist tendencies
self-deceiving, easily lost in inner chaos
capable of devoting self to an ideal
psychically and physically oversensitive
self-sacrificing or martyr-like temperament
needs quiet and meditative retreats

PLUTO RETROGRADE:
suppressed desire and anger, explosive tendencies
alienated, antisocial, misfit tendencies
self-destructive, turns energy inward
easily loses contact with one's own depths
courageous explorer of the psyche
deep psychological insight and perceptiveness
withdrawn, private, reclusive
compulsive or obsessional temperament
capable of powerful, transforming emotional states
endurance, considerable resourcefulness under stress
self-regenerating

For further information about retrograde planets in general and the meaning of each retrograde planet, see Bil Tierney's *Dynamics of Aspect Analysis.*

2.

Determining Planetary Strength

Planets vary considerably in regard to strength; some influence us more than others. Those planets which dominate our charts deserve more attention than those more weakly positioned or aspected. Yet other planets may be highlighted because of their extraordinarily weak placements.

B1. SUN SIGN & HOUSE
(Circle answer.)

The meaning of the Sun has been discussed in section A7, in relationship to the Moon. As the center of consciousness, our Sun position indicates how we integrate the many facets of our experience into a unity of perception. As our primary energy source, it tells us the nature of our drive toward personal fulfillment and the means by which we develop the will to satisfy our desires. Because the Sun is the ego, our conscious awareness of our personal identity, its position in the chart expresses the kinds of experiences which contribute to our individuality and our pride and help us to achieve recognition. In a female's chart, the Sun also represents the animus,

the image of the male, which she may express overtly as well as experience through her father and through the roles of other important men in her life.

The sign position of the Sun indicates *how* we seek to express ourselves, develop ourselves, fulfill ourselves, and assert our will and power to shape our environment. The house position indicates the area of life in which we choose to focus the energy of our Sun sign and fulfill the purpose which it represents. Aspects indicate ego strength and the ease or difficulty we experience in satisfying our primary drives and gaining control over our lives.

B2. MOON SIGN & HOUSE
(Circle answer.)

The meaning of the Moon has been discussed in section A7, in relationship to the Sun. As the emotional energy which fuels the conscious drive of the Sun or subverts the Sun from achieving its conscious purpose, the Moon indicates the nature of our instinctual responses to the world around us, as well as our particular emotional needs and our desires to nurture and be nurtured. As the feminine principle, the Moon is the mother image which we carry within our psyches and which corresponds to our perceptions of our own mothers (or fathers, if the father is the most nurturing parent), as well as the most important females in our lives. In a woman's chart, the Moon indicates how she experiences her role as a woman and/or a mother; it is often as important as the Sun in determining her identity. In a man's chart, the Moon is the primary indicator of the kind of woman with whom he is likely to experience emotional satisfaction.

The sign position of the Moon describes *how* we habitually respond to other people and to the circumstances of our lives, as well as *how* we experience our emotions and seek emotional fulfillment. Its house position corresponds to the area of life in which we operate most unconsciously, according to

past patterns and instinctive responses; in this house, we need to be receptive to our feelings and function on an emotional level, nourishing ourselves and other people and attempting to build a secure base of operations for ourselves. Aspects to the Moon indicate the ease or difficulty with which we experience, accept and utilize our feeling and habit patterns, respond to others, and satisfy our emotional needs.

B3. SUN RULER: ITS SIGN & HOUSE

The ruler of the Sun sign is an important planet in a chart because it expresses how (sign) and in what area of life (house) we apply the energies of our natal Sun position.

B4. ASCENDANT RULER: ITS SIGN & HOUSE

Unless a planet is rising in a chart, the ascendant ruler and its position by sign, house and aspect is the key to physical appearance, the general health of the body, and the characteristics of the personality which we most overtly display. Like the ascending sign and the Sun sign, the ascendant ruler is also linked to our conscious sense of identity. On a higher level, it indicates the way in which we seek to fulfill the aspirations indicated by our ascending sign.

B5. PLANET IN OWN SIGN
(Circle answer.)

A planet in its own sign, particularly an inner planet, has a dominant influence in the chart. Because it functions so easily in its own sign, both the planet and the sign are emphasized. This may not, however, be the best placement for a planet, in terms of the overall balance of the personality, because it indicates an extreme way of functioning. Mercury in Gemini, for example, may indicate considerable verbal ability, a hunger for knowledge and a wide range of skills,

but may also suggest excessive nervousness, restlessness, scatteredness, talkativeness or superficiality.

Because it is so powerful, a planet in its own sign in our chart is likely to influence the profession we choose and how we function within that profession. Consider, for example, the obvious influence of Bob Dylan's Mercury in Gemini, Rod McKuen's Venus in Taurus, Ingrid Bergman's Venus in Libra or Moshe Dayan's Mars in Aries.

B6. PLANET IN OWN HOUSE
(Circle answer.)

A planet in its own house is nearly as significant as a planet in its own sign because it is "at home" in the area of life which it most influences. Just as an ambitious, success-oriented person is "at home" on the job or a dedicated student in school or an aggressive, physically active person on the football field, so Saturn is "at home" in the 10th house, Jupiter in the 9th house, and Mars in the 1st house. A planet in its own sign *and* its own house (e.g., Venus in Taurus in the 2nd house) or a planet in its own house *and* on an angle (e.g., Moon on the I.C.) is, of course, especially powerful.

B7. PLANET RISING
(Circle if less than 2 degrees above or 6 degrees below ascendant.)

A planet rising in the chart is similar in meaning to the ruler of the ascendant, but usually overrides it in importance because of its angular placement. Not only does it influence the physical appearance and the health of the body, but it also, at least as much as the Sun, contributes to our sense of identity, to the "I am" which is the source of ego strength and pride. Because the ascendant is the transmitter of the chart, the point at which we make contact with the outside world and express ourselves outwardly, a planet on the ascen-

dant provides a channel for our self-expression and indicates the means by which we seek to make our presence felt to other people.

B8. PLANET ON MIDHEAVEN
(Circle if less than 2 degrees before
or 6 degrees after the midheaven.)

A planet on our midheaven or M.C. has an overriding influence upon our aim in life and our drive to achieve, as well as upon the nature of our profession or public activities. The nearer a planet is to the M.C., the more likelihood there is that we will succeed in an endeavor related to the use of that planetary energy. The orb of a conjunction to the M.C. should extend further into the 10th house than into the 9th house, because the 9th house is related more to the desire for exploration and understanding than it is related to the desire for public achievement and recognition.

In the total population, we can expect that less than 5.5% (1/18) of all people will have a planet within one degree of their M.C. In Jansky's *Horoscopes Here and Now*, a collection of the charts of one hundred celebrities of the 20th century, 13% (nearly 1/8) have a planet in this position. Judy Garland's Uranus, John Lennon's Pluto and Helen Keller's Uranus are all positioned precisely on their M.C.'s.

B9. PLANET ON NADIR
(Circle if less than 1 degree before
or 2 degrees after nadir.)

A planet on the nadir or I.C. indicates direct access to the unconscious and to past experience, as well as an overpowering need for emotional security, a need which must be fulfilled according to this planet's nature. We need to express its energies in our private lives, through the interactions we experience with family members, through the nature of the

home base which we establish, and through the activities in which we engage in our homes or in other domestic settings.

Although not outwardly apparent to people who do not know us intimately, this planet is nevertheless an important influence upon us, determining the ways in which we feel "at home" with ourselves or feel rooted in our environment. It is also suggestive of the role of the mother or most nurturing parent in our lives, as well as the influence of early childhood and of our heredity. Often a channel which allows us to draw from the collective unconscious and from the experience of former lives, a planet on our I.C. is a key to how we may nourish and enrich our inner being and generate the psychic energy which feeds all other parts of ourselves.

B10. PLANET DESCENDING
(Circle if less than 1 degree before or 2 degrees after descendant.)

A planet on the descendant denotes a more than average need to form one-to-one relationships, not only in love but also through friendships and professional activities. The nature of this planet and its sign indicate qualities in ourselves which we do not easily recognize or express, but which we look for in the people with whom we form the closest ties. We need to enter relationships with people who express this planetary energy, or involve ourselves in relationships characterized by this planetary energy, because through these kinds of interactions we learn to own the part of ourselves which we disown or project, and to express it in its most positive manner.

B11. STATIONARY PLANET
(Circle answer.)

A planet is stationary if its speed has decreased to less than 1/10 of its normal motion, and the ephemeris indicates that in the next few days it will be turning either retrograde

or direct. An outer planet may be stationary, positioned at the same minute of a degree, for as long as a week; an inner planet will usually be stationary for less than 24 hours.

A stationary planet indicates a powerful focus or concentration of energy which may dominate all other planetary energies in a chart because of its compulsive or obsessive nature. A person may easily become stuck in a pattern of expressing this particular planet in a blind and rigid manner, at the expense of satisfying other parts of his or her personality; on the other hand, he or she may use its concentrated energy to achieve in whatever house it functions in the chart.

Carl Jung had a stationary Mars in Sagittarius in his 11th house and devoted himself singlemindedly to exploring the collective psyche. (The author, who has a stationary Mercury in Virgo in the 9th house, conjunct Venus and Saturn, is obsessed with organizing, clarifying, writing and publishing the details of her astrological and psychological understanding. Only the art of synthesis can keep her master of, rather than slave to, the hundreds of details which comprise a natal chart.)

B12. SOLE DISPOSITOR

The sole dispositor is a planet in its own sign which disposits the other planets in a chart. If two planets reside in their own sign, or if a mutual reception occurs (planet A in planet B's sign, planet B in planet A's sign), there cannot be a sole dispositor. However, if two planets involved in a mutual reception disposit all eight other planets in the chart, the mutual reception may be considered a "mutual dispositor." (See section C for more information on mutual receptions.) A planet in its own sign is more powerful if it is *also* a sole dispositor.

To determine if there is a sole dispositor in a chart, begin with any planet in the chart and look to the planetary ruler of its sign. Then, in turn, look to the ruler of that planet's

sign, and so on around the chart until you can go no further. If you reach the planet in its own sign before you have covered all the planets in the chart, go back to the planets you have not covered and trace each until you reach either the planet in its own sign, a mutual reception or a planetary circle such as: *Moon in Sagittarius, Jupiter in Virgo, Mercury in Leo, Sun in Cancer, Moon in Sagittarius.* If such a circle occurs, you will not have a sole dispositor, even if a planet is in its own sign.

Consider the planetary positions in an example chart which has Jupiter in Sagittarius. Because Jupiter is in its own sign, it may be a sole dispositor. But because of the presence of a mutual reception, we discover that it is not:

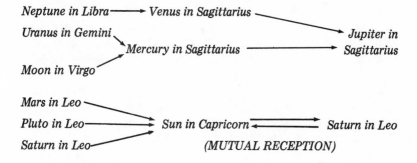

B13. MOST ASPECTED PLANET

The most aspected planet in a chart is intensified in importance because of its many channels of expression. This is particularly true if the planet makes at least six major aspects. Its links to other planets, signs and houses are gateways through which its energy can be utilized by other parts of the personality and in other areas of life besides the house in which it is placed and the house which it rules.

B14. UNASPECTED PLANETS
(Circle answer.)

An unaspected planet, a planet which makes no *major* aspects to other planets in the chart, is of particular significance because of its lack of integration with the rest of the chart. Frequently, it operates autonomously and automatically, in a disconnected and compulsive manner, driving a person to express its one particular planetary energy without regard for the other sides of his or her nature. At other times, its expression remains latent, cut off from the self-image and self-expression.

People with unaspected Mercury may have difficulty making contact or being understood in oral or written communication. If Venus is unaspected, they may either lose themselves completely in a love relationship or deny love altogether in their lives. With Mars unaspected, they may seem to lack self-assertiveness, anger or sexual desire for long periods of time, and then burst into a frenzy of aggressive behavior and sexual activity. Those people who have an unaspected Sun usually must struggle throughout their lives to remain aware of and draw upon their energy and will; they often feel disconnected from themselves.

Most people who have an unaspected planet must exert considerable effort to integrate that planet's energy into their lives. Minor aspects to the unaspected planet may be a help, as well as aspecting transits and progressions. Close relationships with people who have planets trine or sextile their unaspected planet will also aid them in expressing the unaspected planet in a more beneficial manner.

B15. OTHER FOCAL PLANETS
(Circle answer, even if noted in aspect
configurations or planetary patterns in section A.)

In addition to the planets already discussed in section B, a planet should be considered focal, and therefore emphasized in the chart, if it is:

a) the focal planet of a t-square or yod

b) the "handle" of a bucket or fan, or the "engine" of a locomotive

c) the pivotal planet linking two aspect configurations (e.g., in a chart with both a t-square and grand trine, the planet that occurs in both configurations, and is therefore a key to integrating the two).

The central or cutting planet in a bundle or bowl pattern, and the trigger (the planet making the closest trine or sextile to a t-square or grand cross configuration) can also be considered focal planets, although they are not as important as the planets mentioned above. List these only if the natal chart has few planets in positions of emphasis; otherwise, you will find yourself giving special importance to too many planets, without any means for distinguishing between those of primary importance and those of secondary importance.

3.

Aspects & Other Chart Variables

Apart from assessing the chart as a whole and individual planetary placements, we need to understand the active dynamics of the personality as indicated by the interrelationship of the planets and other chart variables. Aspects in particular indicate how different facets of a personality cooperate and conflict, interfering with or enhancing the expression of the planets.

C1. PREDOMINANT TYPE OF ASPECT
(How many?)

In many charts, a balance of conjunctions, sextiles, squares, trines and oppositions occur, perhaps three of each, in which case the predominant kind of aspect is not important. However, when there is a significantly larger number of one kind of aspect in relation to any other kind of aspect, the nature of this aspect is of considerable importance in the life of the individual in question. He or she will tend to operate in the manner of this aspect more frequently than in the manner of the four other major aspects.

People who have conjunctions predominating in their charts are highly focused, able to lose themselves in their own concerns and operate with little external motivation. They are capable of singleminded concentration, but may also tend to lose perspective and venture into narrow or blind alley, benefiting little from the influence of others.

People who have sextiles predominating are generally quite self-expressive, with creative minds that are able to relate broad realms of experience. They may, however, need a little spurring in order to develop their minds and their communication abilities to their best advantage.

Predominating squares indicate people who have experienced many crises throughout their lives and who are motivated to act in order to overcome obstacles. They are capable of a high degree of achievement, but may waste their energy by trying too hard and battling themselves. They may need to learn to relax occasionally and to use their energy in a more flowing and self-preserving manner.

A predominance of trines occurs in the charts of people whose lives are relatively easy and whose talents are many. But because they have not had to confront many challenges which required them to mobilize their energy or deepen their awareness, they may easily become stuck in comfortable but static patterns of behavior and thought. They need to be jolted out of their complacency and urged to develop themselves.

Finally, a large number of oppositions in natal charts indicate people who tend toward extremes and contradictions in behavior, but who strive for balance and for understanding of themselves and their personal relationships. Seekers of meaning, they are capable of profound insight and inspiring revelations. However, they may need to learn to focus their energies on their own pursuits, and to re-own the qualities which they project onto other people.

C2. ABSENCE OF A TYPE OF ASPECT

In addition to the predominant type of aspect in a chart, the absence of a major aspect also reveals how individuals use their energies. Frequently, such minor aspects as quintiles, noviles and semi-sextiles, if activated, can compensate for a lack of sextiles or trines. Semi-squares, and to some extent, inconjuncts (which may be felt as a semi-conscious irritation, but which may not lead to any overt changes in activity or understanding) may compensate for a lack of squares or oppositions. An absence of conjunctions is similar to a predominance of oppositions and vice versa; likewise, an absence of trines and sextiles is similar to a predominance of squares; an absence of squares, to a predominance of trines and sextiles.

People who have no conjunctions have difficulty focusing their energies on a particular project or area of life. They are versatile but scattered, and they need a purpose or goal with which all parts of themselves can identify.

People who lack sextiles frequently are uncomfortable operating in creative or intellectual realms. They often have to strive consciously to develop their mental abilities and to express themselves freely through communication and productive activities.

An absence of squares occurs in the charts of those who prefer to take the easy path rather than grow through the overcoming of obstacles. These people need to set up challenges for themselves and to make an effort to break out of habit patterns which do not further their growth.

Trines are absent in the charts of individuals who are at odds with themselves or other people and must invest considerable energy into their relationships and activities in order to find satisfaction. They need to learn to regenerate their energy and to function in a more moderate and balanced manner.

Finally, a lack of oppositions indicates people who are in touch with themselves and are not dependent upon others to express the qualities which they have not developed. However, because they are so highly subjective and content with a somewhat simplistic view of themselves and their personal relationships, they can benefit from deepening their understanding and broadening their perspective.

C3. CONJUNCTIONS WITHIN 3 DEGREES
(Indicate orb. Circle if less than 1½ degrees.)

The closer an aspect is, the more it influences the personality. Because conjunctions are the strongest aspects, indicating a blending of two planetary energies, a close conjunction will be one of the most significant aspects in a chart. Consider a conjunction within three degrees to be as important as a sextile, trine, square or opposition with half that orb, and a conjunction within 1 degree to be even more powerful.

C4. OTHER MAJOR ASPECTS
WITHIN 1½ DEGREES
(Indicate orb. Circle if less than 1 degree.)

Because energy patterns indicated by the closest aspects in a chart predominate over those indicated by aspects of weak orb, we should always begin our interpretation of aspects by focusing on the more exact ones. Consider major aspects within 1½ degrees (1 degree for the sextile) to be close, those within 1 degree (30 minutes for the sextile) to be nearly exact. A conjunction, square, trine or opposition within 30 minutes will almost always be one of the 5-8 most essential characteristics of a chart, and if less than 10 minutes, may dominate the chart entirely if the chart contains few outstanding features.

In listing close aspects, note which ones are applying (the faster moving planet approaching the same degree of the slower moving planet) and those which are separating (the

faster moving planet departing from the degree of the slower moving planet). Applying aspects will be more powerful than separating aspects of the same orb, because by progression they become more exact after birth.

Close or exact aspects in our natal charts indicate patterns of thinking, feeling or acting which are so natural to us that they often operate without our conscious awareness, sometimes defying our belief in our freedom to direct our planetary energies. These patterns may feel like traps if we fight them, for they are so much a part of ourselves that they will struggle for expression, but if we cooperate with them we can channel their expression to our advantage. An aspect, after all, is an energy link; once such a link occurs in a chart, the two planets in connection can be expressed in a multitude of ways and still be true to their basic nature. A square, once we have learned to translate it into effective action, can bring the benefits of a trine; an opposition, once understood, can result in the synthesizing blend and focus of a conjunction; even a trine can be infused with the motivation of the square once we develop the awareness and the desire to transmute its energies.

C5. IMPORTANT MINOR ASPECTS
(Note those which are exact.)

If we were to calculate and delineate every minor aspect in a chart, we would clutter our brains with so many minor considerations that we would easily lose perspective on the chart's most essential characteristics. However, certain minor aspects may be worth our attention; their importance will depend upon their exactitude, as well as the nature of the major aspects which the chart contains.

Since we normally allow a 1-2 degree orb for most minor aspects, we should consider minor aspects within 30 minutes to be close ones, and those within 15 minutes to be at least as important as major aspects with orbs of two degrees or more.

If a chart has few trines or sextiles, close semi-sextiles, quintiles and biquintiles will take on added significance, for they will indicate potential opportunities and talents; if a chart has few squares or oppositions, the semi-squares will merit our attention, for they will point to sources of tension and motivation which can aid the individual in using his/her trines and sextiles advantageously.

The inconjunct should be considered a minor aspect rather than a major aspect because it is not based upon the even division of a circle by a numeral, and it does not seem to influence us as overtly as do the squares, trines, conjunctions and oppositions. It does, however, merit a larger orb than the other minor aspects—four degrees normally, and one degree to be considered exact. The inconjunct (also called the quincunx) and the semi-square are generally the most powerful of the minor aspects; the sesquiquadrate, quintile and biquintile are also quite significant.

The most commonly used minor aspects are as follows, in order of importance:

ASPECT	DEGREES	KEYWORDS
Inconjunct or Quincunx	150	misaligned or out-of-gear; subtle irritation; psychosomatic symptoms; semi-conscious tension promoting creative productivity
Semi-square	45	mounting friction and motivation; a weak but quite obvious square
Quintile & Biquintile	72 144	individualistic expression; creative capacity to synthesize and transform diverse influences
Sesquiquadrate	135	mounting friction, especially influencing understanding and relationships; similar to a semi-square
Semi-sextile	30	emerging tension and creativity; pre-integrative, often disturbing
Septile and Biseptile	51°25′ 102°50′	fateful; compulsive; occult (little is known about this aspect)
Novile	40	gestation; potential for birth of new forms

The interpretation of minor aspects is not usually necessary for effective chart synthesis. Use them only if you have mastered the major aspects, or if you find the major aspects in a chart to be so weak in orb or so few in number that only a study of the minor aspects will enable you to grasp the energy patterns operating within the individual in question. People of high intelligence and creativity, with esoteric and spiritual leanings may use their minor aspects at least as frequently as their major aspects. With these people, the minor aspects may be given greater importance.

C6. PARALLELS
(Note those which reinforce existing aspects.)

Parallels are often overlooked because they represent a dimension of space which is not discernible on a two-dimensional chart form. Indicating the distance planets are located north or south of the equator, they are determined by consulting tables of declination found in most ephemerides. Because parallels have a one degree orb, a planet 18 degrees north and a planet 19 degrees north are considered to be in parallel; a planet 7 degrees south and one 6 degrees south are also in parallel, but one 6 degrees south and one 6 degrees north are said to be in contraparallel.

Similar to conjunctions, parallels indicate a blending of energies, but unlike conjunctions they are often latent until one or both planets are aspected by transits or progressions. Contraparallels operate like weak oppositions and are also activated by transits and progressions.

Parallels should be considered significant if:

1) they occur between two planets already in conjunction, in which case they reinforce and strengthen the conjunction.

2) they occur between two planets already linked by another major aspect, in which case they reinforce the aspect and

also denote the potential for the two energies to be blended harmoniously.

3) they occur between two planets not in major aspect, which are nevertheless both strongly placed in the chart (perhaps one rising and the other at the focal position of a t-square).

Parallels by themselves are usually not outstanding features of a natal chart. List them here only if they give added emphasis to planets or aspects already noted above.

C7. MUTUAL RECEPTIONS
(Circle answer.)

A mutual reception occurs when one planet is located in another planet's sign, and the second planet is located in the first planet's sign. Frequently overlooked, the mutual reception has the power and meaning of a conjunction, with additional advantages that the conjunction doesn't have. Each planet in a mutual reception is capable of functioning within the sign and house of the other planet; its influence is not limited to the house in which it is placed and the house which it rules. This additional avenue of expression means that a connection is established between the planets, signs and houses involved in a mutual reception, a connection which allows them to operate together and which aids in the resolution and harmonious expression of any squares or oppositions existing between them.

The significance of mutual receptions should not be underestimated. Frequently, they point to central characteristics of the personality which may or may not be evident in the rest of the chart. Consider, for example, Liz Taylor's Moon in Scorpio in the 2nd house and Pluto in Cancer in the 10th house, Bobby Fischer's Mercury in Aquarius in the 8th house and Uranus in Gemini in the 11th, Carol Burnett's Mercury in Aries in the 1st house and Mars in Virgo in the 6th, and Edgar Cayce's Venus in Pisces in the 7th house and Neptune in

Taurus in the 9th. Can we deny the importance of these mutual receptions in their lives?

C8. LUNAR NODES
(What sign and house? Circle answer.
List major aspects within 2 degrees.)

No interpretation of an astrological chart should be given without noting and delineating the positions of the Moon's nodes. Not only their sign and house positions, but also their aspects reveal crucial issues which we must confront during our lifetimes, if we are to break free from the pull of the past and fulfill our purpose in this incarnation.

Not only the twelfth house, but also the South Node of the Moon indicate the strengths and weaknesses which we have brought into this incarnation. The South Node is our line of least resistance; we tend to retreat into expressing its sign and house because we feel secure functioning on that level, and because it is so natural for us to express those energies and pay attention to that area of our life. However, in this lifetime we are not meant to focus upon our South Node qualities and interests, because doing so leads us to regress and eventually limits the opportunities open to us. We begin to feel bound by the past and become frustrated and unsatisfied. Rather, our task in this lifetime is to learn to use our South Node abilities in order to fulfill the meaning of the North Node in our chart, according to its placement by sign and house, and also according to the placement of its dispositor.

Developing our North Node is not usually easy for us, particularly if it squares or opposes planets in our chart; we feel drawn continually back to the sign and house of the South Node. But by actively expressing the energies of the North Node's sign, and by developing our capacity to operate effectively in the area of life denoted by the North Node's house, we attract the helping, healing energies of the universe to ourselves. We awaken the talents and the strengths which

we were born to manifest and experience the immeasurable satisfaction of having fulfilled our personal life task. For complete information on the lunar nodes, see *The Astrology of Self-Discovery* by Tracy Marks, published by CRCS Publications, and *The Astrologer's Node Book* by Donna Van Toen.

Note on your worksheet not only the positions by sign and house of the lunar nodes, but also close aspects which they make to planets in the chart. Conjunctions to the North Node indicate the planetary energies which we most need to develop constructively; conjunctions to the South Node indicate planetary energies which are easy for us to express but which we do not need to emphasize during this lifetime. Any other aspects to the nodes denote the ease or difficulty which we may experience in utilizing our South Node to fulfill the meaning of our North Node.

The house placement of the ruler of the sign in which the South Node is located reveals a secondary area of life upon which we have focused in the past, and which we now use as a refuge; the house placement of the ruler of North Node's sign reveals a secondary area of life where we need to apply the lessons we learn from our North Node.

4.

Preliminary Synthesis

The purpose of this section is to help you begin to synthesize some of the astrological variables discussed so far.

D1. STRONGEST PLANETS
(How many counts? Circle if more than 4.)

Count the number of times you have listed a planet in sections B3–15; if you have circled a planet, count it double. Add to this number 2 counts for the Sun and 1 for the Moon, to correspond to their importance in all natal charts. The strongest planet in the chart is likely to be the one which receives the most counts. More than 4 counts per planet will indicate that it dominates the chart; frequently, two or more planets will be equally dominant.

D2. STRONGEST SIGNS
(How many counts? Circle if more than 4.)

This is frequently difficult to determine because of the varying weights of the planets in each chart. The best method

is to count 1 for each sign in which a planet is placed and also 1 each for the ascendant and midheaven; add 2 additional counts for the Sun sign, 1 for the Moon sign, and 1 for the sign of the most dominant planet (determined in D1.)

D3. STRONGEST HOUSES
(How many counts? Circle if more than 4.)

Use the same system for determining the strongest house or houses as you did for the strongest signs, adding additional counts for the houses of the Sun, Moon and most dominant planet. Ignore the ascendant and midheaven.

D4. STRONGEST ASPECT
(Circle if less than 30 minutes.)

Note here the most exact aspect in the chart and its orb. Include aspects to the angles and nodes. If the most exact aspect is a trine or sextile, then note also the closest square or opposition, which indicates the most dynamic expression of energy operating within the individual.

5.

Additional Considerations

There are many other astrological variables that are useful in interpreting a chart in a thorough and detailed manner, but are not essential in synthesizing a chart and understanding its primary characteristics. The following additional considerations, however, may be noteworthy in certain charts:

1) *THE TWELFTH HOUSE COMPLEX* (consisting of the planets positioned in the 12th house, as well as the 12th house ruler) reveals hidden factors which shape us, providing an added source of strength or resulting in irrational and often self-destructive behavior. See *The Twelfth House* by Tracy Marks for further information.

2) *SOLAR ECLIPSES* occur when the New Moon conjuncts its nodal axis; *LUNAR ECLIPSES*, when the Full Moon conjuncts its nodal axis. Since solar and lunar eclipses each occur approximately twice a year, we must consult an ephemeris or a table of eclipses in order to determine whether or not a person born under a New Moon or Full Moon was born within 24 hours of an eclipse. People with eclipsed Suns generally experience a weakness of vitality,

will and self-esteem, but are also capable of using their physical energy and developing their identity in a highly unique manner. People with eclipsed Moons are usually emotionally unstable and dependent, but they have access to transformative levels of feeling and intuition which they can, if they are able, effectively channel into creative activities.

The position of the last solar eclipse before birth usually indicates an area of life in which we experience continual crises, in which we feel compelled to test our limits and develop ourselves. See Robert Jansky's *Interpreting the Eclipses* for more information.

3) *ANGULAR, SUCCEDENT AND CADENT HOUSES* are similar in meaning to cardinal, fixed and mutable signs. A predominance of planets in angular houses (1, 4, 7 and 10) denotes a powerful urge to mobilize one's energy, initiating activities related to the major issues of life—identity, home and family, love and marriage, and career. A predominance in succedent houses (2, 5, 8 and 11) indicates the urge to satisfy one's personal desires, and the capacity to concentrate energy and follow through with the tasks at hand. Finally, a predominance of planets in cadent houses (3, 6, 9 and 12) suggests an individual who is concerned with his/her reactions to experience, with conceptualizing and clarifying his/her personal reality.

4) *THE MOST ELEVATED PLANET*, the one closest to the M.C., may be significant if few planets are prominent in a chart; this planet indicates the nature of an individual's aspirations, and how he or she is likely to achieve.

5) *THE EASTERN/WESTERN DIVISION* of planets in a chart is worth noting if a strong imbalance occurs. Seven or more planets in the eastern (left) hemisphere suggest an individual whose life is in his/her own hands; seven or more planets in the western (right) hemisphere indicate a life which is very much influenced by other people.

6) *SUN/MERCURY CONJUNCTIONS* deserve special emphasis when the orb of the conjunction is less than 4 degrees. When the orb is ½–4 degrees, Mercury is considered in "combust." The individual with such a conjunction is so mentally overstimulated and so overly subjective that he or she frequently has difficulty thinking and communicating clearly. However, when Mercury is within 30 minutes of the Sun, its power is intensified; the mind is sharpened and the capacity for genius is evident.

7) *THE MIDPOINTS* of two planets are the degrees of the zodiac which are equidistant from both planets. Each pair of planets has both a near and far midpoint, one located within the shortest distance between them and the other 180 degrees away.

Because there are dozens of midpoints in any chart, only the most significant ones need be considered in synthesis. The most significant is usually the midpoint of a square which conjuncts a planet in the chart, dividing the square into two semi-squares. The planetary midpoint is energized by the square, and is a key to using the square constructively. A planetary midpoint of an opposition (if it forms a t-square), trine or sextile operates in a similar manner.

In addition to the above factors, many other astrological variables may be considered when synthesizing a chart. The author regards some of these variables to be of minor importance, and others to be of questionable validity.

OF MINOR IMPORTANCE: masculine/feminine signs, the part of fortune, the signature, planetary nodes, the vertex, fixed stars.

OF QUESTIONABLE VALIDITY: quadrant emphasis, the traditional north/south interpretation, exaltations and detriments, oriental planets, decanates, critical degrees, mental

chemistry, Promethean or Epimethean Mercury, Venus Hesperus or Lucifer.

Astrology students should study and research the above-mentioned factors before determining whether or not to use them in chart interpretation.

6.

How to Synthesize

DETERMINING THE PRIMARY CHARACTERISTICS

Once we have completed steps A–D of the worksheet, we will want to determine which of the 15, 20 or 25 characteristics we have listed are the most significant. If a chart has many outstanding features, our worksheet will be crowded with answers, many of them circled to denote their special importance. With such a "strong" chart, we will need to be particularly selective. A planet in its own house or 5 degrees from the midheaven will not be as important as it would in a chart with few dominant planets.

In order to reduce our list, we must re-assess the answers which we have circled, grouping together those which are related in meaning, such as 8 earth counts and a grand earth trine. Frequently, we will discover a number of closely related characteristics, each one reinforcing the other. These will help us to grasp the chart's overall unity.

If this first step yields only 3, 4 or 5 characteristics, we may then want to pay attention to the answers which we have

not circled. Which ones are the most obvious in the chart? The most pronounced? The most extreme or unusual? No one set of guidelines can be applied to each individual chart, but the following list may be useful in selecting from the worksheet important characteristics which we have not circled:

a) 2 or 5 counts of an element

b) 3 or 6 counts of a mode

c) Sun ruler or ascendant ruler

d) 3 retrograde planets

e) loosely defined pattern

f) planets in the last 6 degrees of the 9th or 12th house or 6-10 degrees into the 10th or 1st house

g) planets in last 3 degrees of the 3rd or 6th house or 2-4 degrees into the 4th or 7th house

h) most aspected planet, if more than 5 aspects

i) predominant aspect, if highly emphasized

j) conjunctions within 1½-3 degrees orb (especially to Sun or Moon)

k) other major aspects within 1½-3 degrees orb

l) absence of a type of aspect

If our first step yields more than 8 characteristics, we may then want to weigh their comparative strengths. In time, as we gain more practice interpreting charts, our intuition will guide us quickly through these preliminary steps; but now, at the beginning stage, we will want to determine which characteristics on our revised list are first priority. We can do so by omitting all of the following:

a) 1 or 6 counts of an element

b) 2 or 7 counts of a mode

c) very loose aspect configuration (wide orbs)

d) conjunctions 1-1½ degrees

e) planet in own house

f) 0 or 4 retrograde planets

g) other major aspects over 30 minutes, if one or more aspects with smaller orbs occurs in the chart

h) ascendant, if sign, ruler and natural house are weak.

If we end up with only 5 factors, or as many as 9 or 10, we should not be concerned. Each chart is unique, and no rules can take into account all the problems which may arise in synthesis. For this reason, even if we have an abundance of circled answers, a few of the answers which we have not circled may be worth considering if they are notable, such as the most aspected planet aspecting all 9 other planets or 10 squares in a chart with 15 major aspects. Probably the best way to familiarize ourselves with the synthesis worksheet is to begin by practicing with our own charts.

THE ROLE OF INTUITION

Although the method of synthesis described here can help us to determine a chart's primary characteristics, such a rational approach is usually not sufficient for conducting meaningful readings. Only by drawing upon our intuition as well as our intellect can we penetrate to the essence of a chart and interpret it in a vital and relevant manner. As we study a chart, perhaps even as we calculate it, several of its features may "jump out" at us. Whether or not these are characteristics we have noted or circled on our worksheet, we should pay attention to them, for they may lead us to issues which: 1) are particularly significant to our client, or 2) are also personally significant to us, which we understand fully and can express insightfully.

When we interpret a chart, we need a lead, a key feature with which to begin our reading. If our use of the worksheet does not help us to determine which characteristic is indeed the most dominant and therefore the most appropriate starting point, then we should allow our intuition to make the selection. But what if our intuition fails us? What if we do not

know how to draw upon it? Even if we are not naturally intuitive, we can develop our intuitive abilities. By relaxing and emptying our minds as we look at a chart, we can gaze at it as we would a mandala or painting, communing with it as a whole rather than concentrating upon each of its many details. If we feel our attention pulled in one direction or another, we should go with the pull, letting foreground and background shift accordingly. Eventually, the various patterns in the chart and their interrelatedness may become obvious, and new insights will emerge from the depths of our consciousness.

Another way to develop our intuition is to do quick interpretations of a number of charts, without giving our rational minds time to prepare a systematic analysis. By allowing ourselves to become quiet and listen to our first impressions, we can begin to recognize the wisdom of our intuitive understanding, and begin to consult it on a regular basis.

PREPARING TO INTERPRET

Once we have determined the primary features of a chart and listened to the promptings of our intuition, what then? How can we best prepare a reading?

First, we can make sure that we have obtained sufficient background information (marital status, occupation, etc.) from our client so that we can view the chart in a valid context.

Second, we can discover what transits and progressions are influencing the chart now, so that we will know which planets, signs and houses are activated or are now under stress.

Third, we can note what complexities or contradictions occur in the chart and attempt to understand them. What if there are 0 water counts, and the Moon is rising? What if 4 planets occur in Gemini, and Mercury and Jupiter are in Cancer? Most people are complex and even contradictory and may oscillate between two parts of themselves or attempt to express one part without the cooperation of another part.

Fourth, we can pay attention to our negative reactions to various placements or patterns. Why do we have such reactions? How can we interpret these features in a more constructive manner? Certainly Venus conjunct Saturn must have some virtues; certainly a Mars/Pluto square, if channelled effectively, can be a benefit rather than a torment. We should be particularly wary of our negativity if our client has a high water count or a very stressed Saturn and is oversensitive or fearful.

Fifth, we may, in certain charts, be able to group the important features we have selected into two or three larger groups, noting their relationship to each other. Doing so will help us to summarize at the beginning of our reading all that we will be covering, thereby orienting not only ourselves but also our client.

Finally, we can best prepare for a reading by studying or meditating upon each of the chart's primary characteristics. Only by drawing upon our own understanding and consulting astrology texts as a last resort, can we begin to develop our skills as astrologers. If our understanding fails us, and if our books fail us, we should not be ashamed to admit our confusion to our clients, giving them the opportunity to clarify to us and to themselves their own self-understanding.

PART TWO

PRACTICE IN
CHART SYNTHESIS

Introduction

The aim of this section is to provide an opportunity for you to determine the primary characteristics of five example charts, using the synthesis worksheet and comparing your answers to those of the author. The five charts included here are not representative of the kinds of charts that you will be interpreting on a regular basis. Because they are charts of famous people of the twentieth century, people who are notable because of their talents or because of the unusual circumstances of their lives, most of them contain extremes of elements or modes and highly emphasized planets, signs, houses or aspects. Only chart E could be mistaken for the chart of an "ordinary" person; as a result, the significant features of this chart are interpreted at length at the end of the answer section, as a demonstration of how effectively the principles of synthesis operate in practice.

But why, if most of these charts are not "ordinary" charts, are they given here as useful examples? The answer to the above question is twofold. First, these charts are interesting; they are likely to hold your attention and to motivate you to sharpen your astrological skills as you painstakingly learn a

new method for organizing your interpretations. Second, be-
cause the identities of these people are not revealed until the
answer section, you can make your learning experience more
enjoyable and test your knowledge and intuition by guessing
who these contemporary figures are. A hint: charts A and C
are male; charts B, D and E are female.

chart A

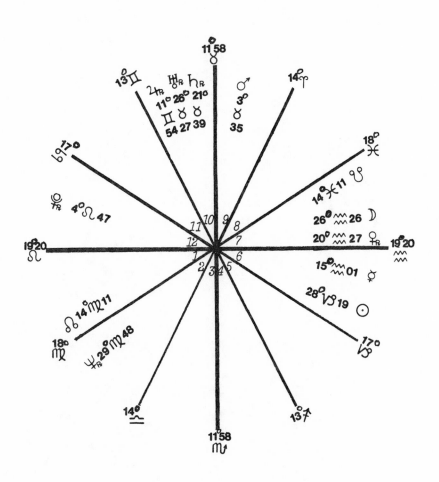

chart B

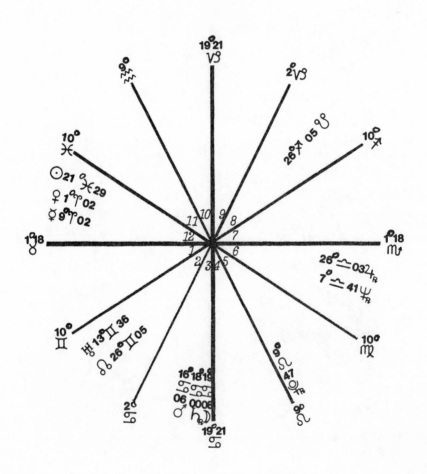

chart C

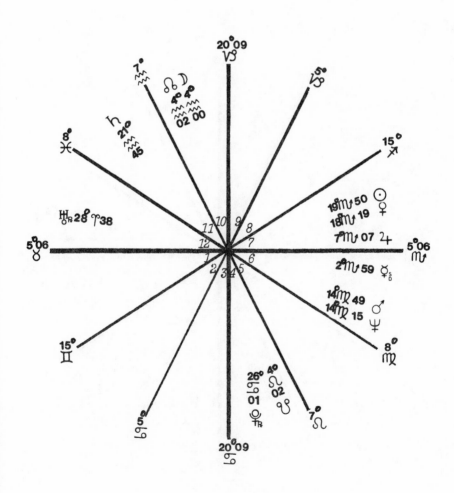

chart D

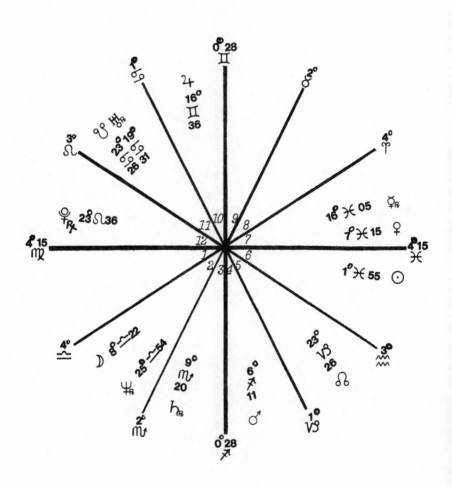

chart E

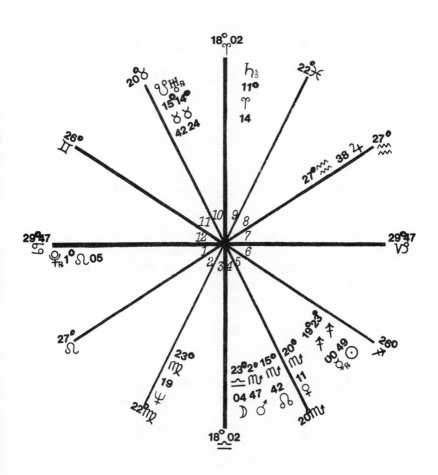

SYNTHESIS WORKSHEET

A. <u>THE CHART AS A WHOLE</u> (p. 23)

 1. PREDOMINANT ELEMENT (p. 23)
 How many? Circle if more than 5/14.

 2. WEAKEST ELEMENT (p. 25)
 How many? Circle if 0 or 1/14.

 3. PREDOMINANT MODE (p. 28)
 How many? Circle if more than 6/14.

 4. WEAKEST MODE (p. 30)
 How many? Circle if 0, 1/14 or 2/14.

 5. PLANETARY PATTERN (p. 31)
 Circle if pattern is clearly defined.

 6. ASPECT CONFIGURATIONS (p. 36)
 Circle answer.

 7. SUN/MOON SIGNS & RELATIONSHIP (p. 47)
 Note aspect or phase. Circle
 if in major aspect.

 8. ASCENDANT/MIDHEAVEN SIGNS (p. 53)
 Circle ascendant.

 9. NUMBER OF RETROGRADE PLANETS (p. 54)
 Circle if 0 or more than 3.

B. <u>DETERMINING PLANETARY STRENGTH</u> (p. 58)

 1. SUN SIGN & HOUSE (p. 58)
 Circle answer.

 2. MOON SIGN & HOUSE (p. 59)
 Circle answer.

B. **3.** SUN RULER: ITS SIGN & HOUSE (p. 60)

4. ASCENDANT RULER: ITS SIGN & HOUSE (p. 60)

5. PLANET IN OWN SIGN (p. 60)
Circle answer.

6. PLANET IN OWN HOUSE (p. 61)
Circle answer.

7. PLANET RISING (p. 61)
Circle if less than 2 degrees above or 6 degrees below ascendant.

8. PLANET ON MIDHEAVEN (p. 62)
Circle if less than 2 degrees before or 6 degrees after midheaven.

9. PLANET ON NADIR (p. 62)
Circle if less than 1 degree before or 2 degrees after nadir.

10. PLANET DESCENDING (p. 63)
Circle if less than 1 degree before or 2 degrees after descendant.

11. STATIONARY PLANET (p. 63)
Circle answer.

12. SOLE DISPOSITOR (p. 64)

13. MOST ASPECTED PLANET (p. 65)
How many aspects?

14. UNASPECTED PLANETS (p. 66)
Circle answer.

15. OTHER FOCAL PLANETS (p. 67)
Circle answer.

C. ASPECTS & OTHER CHART VARIABLES

1. **PREDOMINANT TYPE OF ASPECT**
(p. 68) How many?

2. **ABSENCE OF A TYPE OF ASPECT**
(p. 70)

3. **CONJUNCTIONS WITHIN 3 DEGREES**
(p. 71) Indicate orb. Circle if less than
$1\frac{1}{2}$ degrees.

4. **OTHER MAJOR ASPECTS WITHIN $1\frac{1}{2}$**
DEGREES (p. 71) Indicate orb. Circle
if less than 1 degree.

5. **IMPORTANT MINOR ASPECTS** (p. 72)
Note those which are exact.

6. **PARALLELS REINFORCING ASPECTS**
(p. 74)

7. **MUTUAL RECEPTIONS** (p. 75)
Circle answer.

8. **LUNAR NODES** (p. 76)
Indicate sign & house. Circle answer.
List major aspects within 2 degrees.

D. PRELIMINARY SYNTHESIS (p. 78)

1. **STRONGEST PLANETS**
How many counts?
Circle if more than 4.

2. **STRONGEST SIGNS** How many counts?
Circle if more than 4.

3. **STRONGEST HOUSES** How many counts?
Circle if more than 4.

D. 4. STRONGEST ASPECT
Circle if less than 30 minutes.

E. ADDITIONAL CONSIDERATIONS (p. 80)

F. THE PRIMARY CHARACTERISTICS OF THIS CHART

1.

2.

3.

4.

5.

6.

7.

8.

SYNTHESIS WORKSHEET

A. THE CHART AS A WHOLE (p. 23)

1. PREDOMINANT ELEMENT (p. 23)
How many? Circle if more than 5/14.

2. WEAKEST ELEMENT (p. 25)
How many? Circle if 0 or 1/14.

3. PREDOMINANT MODE (p. 28)
How many? Circle if more than 6/14.

4. WEAKEST MODE (p. 30)
How many? Circle if 0, 1/14 or 2/14.

5. PLANETARY PATTERN (p. 31)
Circle if pattern is clearly defined.

6. ASPECT CONFIGURATIONS (p. 36)
Circle answer.

7. SUN/MOON SIGNS & RELATIONSHIP (p. 47)
Note aspect or phase. Circle
if in major aspect.

8. ASCENDANT/MIDHEAVEN SIGNS (p. 53)
Circle ascendant.

9. NUMBER OF RETROGRADE PLANETS (p. 54)
Circle if 0 or more than 3.

B. DETERMINING PLANETARY STRENGTH (p. 58)

1. SUN SIGN & HOUSE (p. 58)
Circle answer.

2. MOON SIGN & HOUSE (p. 59)
Circle answer.

B. **3.** SUN RULER: ITS SIGN & HOUSE (p. 60)

4. ASCENDANT RULER: ITS SIGN & HOUSE (p. 60)

5. PLANET IN OWN SIGN (p. 60)
Circle answer.

6. PLANET IN OWN HOUSE (p. 61)
Circle answer.

7. PLANET RISING (p. 61)
Circle if less than 2 degrees above
or 6 degrees below ascendant.

8. PLANET ON MIDHEAVEN (p. 62)
Circle if less than 2 degrees before
or 6 degrees after midheaven.

9. PLANET ON NADIR (p. 62)
Circle if less than 1 degree before
or 2 degrees after nadir.

10. PLANET DESCENDING (p. 63)
Circle if less than 1 degree before
or 2 degrees after descendant.

11. STATIONARY PLANET (p. 63)
Circle answer.

12. SOLE DISPOSITOR (p. 64)

13. MOST ASPECTED PLANET (p. 65)
How many aspects?

14. UNASPECTED PLANETS (p. 66)
Circle answer.

15. OTHER FOCAL PLANETS (p. 67)
Circle answer.

C. ASPECTS & OTHER CHART VARIABLES

1. **PREDOMINANT TYPE OF ASPECT**
(p. 68) How many?

2. **ABSENCE OF A TYPE OF ASPECT**
(p. 70)

3. **CONJUNCTIONS WITHIN 3 DEGREES**
(p. 71) Indicate orb. Circle if less than
$1\frac{1}{2}$ degrees.

4. **OTHER MAJOR ASPECTS WITHIN $1\frac{1}{2}$
DEGREES** (p. 71) Indicate orb. Circle
if less than 1 degree.

5. **IMPORTANT MINOR ASPECTS** (p. 72)
Note those which are exact.

6. **PARALLELS REINFORCING ASPECTS**
(p. 74)

7. **MUTUAL RECEPTIONS** (p. 75)
Circle answer.

8. **LUNAR NODES** (p. 76)
Indicate sign & house. Circle answer.
List major aspects within 2 degrees.

D. PRELIMINARY SYNTHESIS (p. 78)

1. **STRONGEST PLANETS**
How many counts?
Circle if more than 4.

2. **STRONGEST SIGNS** How many counts?
Circle if more than 4.

3. **STRONGEST HOUSES** How many counts?
Circle if more than 4.

D. 4. STRONGEST ASPECT
 Circle if less than 30 minutes.

E. ADDITIONAL CONSIDERATIONS (p. 80)

F. THE PRIMARY CHARACTERISTICS OF THIS CHART

 1.

 2.

 3.

 4.

 5.

 6.

 7.

 8.

SYNTHESIS WORKSHEET

A. <u>THE CHART AS A WHOLE</u> (p. 23)

 1. PREDOMINANT ELEMENT (p. 23)
 How many? Circle if more than 5/14.

 2. WEAKEST ELEMENT (p. 25)
 How many? Circle if 0 or 1/14.

 3. PREDOMINANT MODE (p. 28)
 How many? Circle if more than 6/14.

 4. WEAKEST MODE (p. 30)
 How many? Circle if 0, 1/14 or 2/14.

 5. PLANETARY PATTERN (p. 31)
 Circle if pattern is clearly defined.

 6. ASPECT CONFIGURATIONS (p. 36)
 Circle answer.

 7. SUN/MOON SIGNS & RELATIONSHIP (p. 47)
 Note aspect or phase. Circle
 if in major aspect.

 8. ASCENDANT/MIDHEAVEN SIGNS (p. 53)
 Circle ascendant.

 9. NUMBER OF RETROGRADE PLANETS (p. 54)
 Circle if 0 or more than 3.

B. <u>DETERMINING PLANETARY STRENGTH</u> (p. 58)

 1. SUN SIGN & HOUSE (p. 58)
 Circle answer.

 2. MOON SIGN & HOUSE (p. 59)
 Circle answer.

B. **3.** SUN RULER: ITS SIGN & HOUSE (p. 60)

4. ASCENDANT RULER: ITS SIGN & HOUSE (p. 60)

5. PLANET IN OWN SIGN (p. 60)
Circle answer.

6. PLANET IN OWN HOUSE (p. 61)
Circle answer.

7. PLANET RISING (p. 61)
Circle if less than 2 degrees above or 6 degrees below ascendant.

8. PLANET ON MIDHEAVEN (p. 62)
Circle if less than 2 degrees before or 6 degrees after midheaven.

9. PLANET ON NADIR (p. 62)
Circle if less than 1 degree before or 2 degrees after nadir.

10. PLANET DESCENDING (p. 63)
Circle if less than 1 degree before or 2 degrees after descendant.

11. STATIONARY PLANET (p. 63)
Circle answer.

12. SOLE DISPOSITOR (p. 64)

13. MOST ASPECTED PLANET (p. 65)
How many aspects?

14. UNASPECTED PLANETS (p. 66)
Circle answer.

15. OTHER FOCAL PLANETS (p. 67)
Circle answer.

C. ASPECTS & OTHER CHART VARIABLES

1. PREDOMINANT TYPE OF ASPECT
(p. 68) How many?

2. ABSENCE OF A TYPE OF ASPECT
(p. 70)

3. CONJUNCTIONS WITHIN 3 DEGREES
(p. 71) Indicate orb. Circle if less than
$1\frac{1}{2}$ degrees.

**4. OTHER MAJOR ASPECTS WITHIN $1\frac{1}{2}$
DEGREES** (p. 71) Indicate orb. Circle
if less than 1 degree.

5. IMPORTANT MINOR ASPECTS (p. 72)
Note those which are exact.

6. PARALLELS REINFORCING ASPECTS
(p. 74)

7. MUTUAL RECEPTIONS (p. 75)
Circle answer.

8. LUNAR NODES (p. 76)
Indicate sign & house. Circle answer.
List major aspects within 2 degrees.

D. PRELIMINARY SYNTHESIS (p. 78)

1. STRONGEST PLANETS
How many counts?
Circle if more than 4.

2. STRONGEST SIGNS How many counts?
Circle if more than 4.

3. STRONGEST HOUSES How many counts?
Circle if more than 4.

D. **4.** STRONGEST ASPECT
Circle if less than 30 minutes.

E. ADDITIONAL CONSIDERATIONS (p. 80)

F. THE PRIMARY CHARACTERISTICS OF THIS CHART

1.

2.

3.

4.

5.

6.

7.

8.

SYNTHESIS WORKSHEET

A. THE CHART AS A WHOLE (p. 23)

 1. PREDOMINANT ELEMENT (p. 23)
 How many? Circle if more than 5/14.

 2. WEAKEST ELEMENT (p. 25)
 How many? Circle if 0 or 1/14.

 3. PREDOMINANT MODE (p. 28)
 How many? Circle if more than 6/14.

 4. WEAKEST MODE (p. 30)
 How many? Circle if 0, 1/14 or 2/14.

 5. PLANETARY PATTERN (p. 31)
 Circle if pattern is clearly defined.

 6. ASPECT CONFIGURATIONS (p. 36)
 Circle answer.

 7. SUN/MOON SIGNS & RELATIONSHIP (p. 47)
 Note aspect or phase. Circle
 if in major aspect.

 8. ASCENDANT/MIDHEAVEN SIGNS (p. 53)
 Circle ascendant.

 9. NUMBER OF RETROGRADE PLANETS (p. 54)
 Circle if 0 or more than 3.

B. DETERMINING PLANETARY STRENGTH (p. 58)

 1. SUN SIGN & HOUSE (p. 58)
 Circle answer.

 2. MOON SIGN & HOUSE (p. 59)
 Circle answer.

B. **3.** SUN RULER: ITS SIGN & HOUSE (p. 60)

4. ASCENDANT RULER: ITS SIGN & HOUSE (p. 60)

5. PLANET IN OWN SIGN (p. 60)
Circle answer.

6. PLANET IN OWN HOUSE (p. 61)
Circle answer.

7. PLANET RISING (p. 61)
Circle if less than 2 degrees above or 6 degrees below ascendant.

8. PLANET ON MIDHEAVEN (p. 62)
Circle if less than 2 degrees before or 6 degrees after midheaven.

9. PLANET ON NADIR (p. 62)
Circle if less than 1 degree before or 2 degrees after nadir.

10. PLANET DESCENDING (p. 63)
Circle if less than 1 degree before or 2 degrees after descendant.

11. STATIONARY PLANET (p. 63)
Circle answer.

12. SOLE DISPOSITOR (p. 64)

13. MOST ASPECTED PLANET (p. 65)
How many aspects?

14. UNASPECTED PLANETS (p. 66)
Circle answer.

15. OTHER FOCAL PLANETS (p. 67)
Circle answer.

C. ASPECTS & OTHER CHART VARIABLES

1. PREDOMINANT TYPE OF ASPECT
(p. 68) How many?

2. ABSENCE OF A TYPE OF ASPECT
(p. 70)

3. CONJUNCTIONS WITHIN 3 DEGREES
(p. 71) Indicate orb. Circle if less than
$1\frac{1}{2}$ degrees.

4. OTHER MAJOR ASPECTS WITHIN $1\frac{1}{2}$
DEGREES (p. 71) Indicate orb. Circle
if less than 1 degree.

5. IMPORTANT MINOR ASPECTS (p. 72)
Note those which are exact.

6. PARALLELS REINFORCING ASPECTS
(p. 74)

7. MUTUAL RECEPTIONS (p. 75)
Circle answer.

8. LUNAR NODES (p. 76)
Indicate sign & house. Circle answer.
List major aspects within 2 degrees.

D. PRELIMINARY SYNTHESIS (p. 78)

1. STRONGEST PLANETS
How many counts?
Circle if more than 4.

2. STRONGEST SIGNS How many counts?
Circle if more than 4.

3. STRONGEST HOUSES How many counts?
Circle if more than 4.

D. **4.** STRONGEST ASPECT
Circle if less than 30 minutes.

E. ADDITIONAL CONSIDERATIONS (p. 80)

F. THE PRIMARY CHARACTERISTICS OF THIS CHART

1.

2.

3.

4.

5.

6.

7.

8.

SYNTHESIS WORKSHEET

A. THE CHART AS A WHOLE (p. 23)

 1. PREDOMINANT ELEMENT (p. 23)
How many? Circle if more than 5/14.

 2. WEAKEST ELEMENT (p. 25)
How many? Circle if 0 or 1/14.

 3. PREDOMINANT MODE (p. 28)
How many? Circle if more than 6/14.

 4. WEAKEST MODE (p. 30)
How many? Circle if 0, 1/14 or 2/14.

 5. PLANETARY PATTERN (p. 31)
Circle if pattern is clearly defined.

 6. ASPECT CONFIGURATIONS (p. 36)
Circle answer.

 7. SUN/MOON SIGNS & RELATIONSHIP (p. 47)
Note aspect or phase. Circle
if in major aspect.

 8. ASCENDANT/MIDHEAVEN SIGNS (p. 53)
Circle ascendant.

 9. NUMBER OF RETROGRADE PLANETS (p. 54)
Circle if 0 or more than 3.

B. DETERMINING PLANETARY STRENGTH (p. 58)

 1. SUN SIGN & HOUSE (p. 58)
Circle answer.

 2. MOON SIGN & HOUSE (p. 59)
Circle answer.

B. **3.** SUN RULER: ITS SIGN & HOUSE (p. 60)

4. ASCENDANT RULER: ITS SIGN & HOUSE (p. 60)

5. PLANET IN OWN SIGN (p. 60)
Circle answer.

6. PLANET IN OWN HOUSE (p. 61)
Circle answer.

7. PLANET RISING (p. 61)
Circle if less than 2 degrees above or 6 degrees below ascendant.

8. PLANET ON MIDHEAVEN (p. 62)
Circle if less than 2 degrees before or 6 degrees after midheaven.

9. PLANET ON NADIR (p. 62)
Circle if less than 1 degree before or 2 degrees after nadir.

10. PLANET DESCENDING (p. 63)
Circle if less than 1 degree before or 2 degrees after descendant.

11. STATIONARY PLANET (p. 63)
Circle answer.

12. SOLE DISPOSITOR (p. 64)

13. MOST ASPECTED PLANET (p. 65)
How many aspects?

14. UNASPECTED PLANETS (p. 66)
Circle answer.

15. OTHER FOCAL PLANETS (p. 67)
Circle answer.

C. ASPECTS & OTHER CHART VARIABLES

 1. PREDOMINANT TYPE OF ASPECT
 (p. 68) How many?

 2. ABSENCE OF A TYPE OF ASPECT
 (p. 70)

 3. CONJUNCTIONS WITHIN 3 DEGREES
 (p. 71) Indicate orb. Circle if less than
 $1\frac{1}{2}$ degrees.

 4. OTHER MAJOR ASPECTS WITHIN $1\frac{1}{2}$
 DEGREES (p. 71) Indicate orb. Circle
 if less than 1 degree.

 5. IMPORTANT MINOR ASPECTS (p. 72)
 Note those which are exact.

 6. PARALLELS REINFORCING ASPECTS
 (p. 74)

 7. MUTUAL RECEPTIONS (p. 75)
 Circle answer.

 8. LUNAR NODES (p. 76)
 Indicate sign & house. Circle answer.
 List major aspects within 2 degrees.

D. PRELIMINARY SYNTHESIS (p. 78)

 1. STRONGEST PLANETS
 How many counts?
 Circle if more than 4.

 2. STRONGEST SIGNS How many counts?
 Circle if more than 4.

 3. STRONGEST HOUSES How many counts?
 Circle if more than 4.

D. 4. STRONGEST ASPECT
 Circle if less than 30 minutes.

E. ADDITIONAL CONSIDERATIONS (p. 80)

F. THE PRIMARY CHARACTERISTICS OF THIS CHART

 1.

 2.

 3.

 4.

 5.

 6.

 7.

 8.

7.

Author's Answers

Answers listed here were determined by following the rules outlined on the Synthesis Worksheet and in "A Preliminary Note." Please note that factors that would be circled on the worksheet are printed below in **bold** *type.*

CHART A

Horoscope of Muhammed Ali, 1/18/42, 6:30 p.m. C.S.T., Louisville, Kentucky. SOURCE: Horoscope *magazine and Robert Jansky's* Horoscopes Here and Now. *Note that* The American Book of Charts *edited by Lois Rodden gives 1/17/42, 6:35 p.m.*

A1. **6½ earth, 5½ air**
 2. **0 water**
 3. **10 fixed**
 4. **1½ mutable**
 5. locomotive to Sun (despite gap of a wide sextile)
 6. t-square to Mars in Taurus in 9th house, grand earth trine and weak yod to Neptune
 7. Sun semi-sextile Moon
 8. Leo ascendant, Taurus midheaven
 9. 6 retrograde planets

B1. Sun in Capricorn in 6th house
2. Moon in Aquarius in 7th house
3. Saturn in Taurus retrograde in 10th house
4. Sun in Capricorn in 6th house
6. Saturn in 10th, Venus in 7th, Mercury late in 6th
10. Venus in Aquarius descending, 1 degree, 7 minutes
13. Saturn, 7 aspects counting trine to Neptune
15. Sun as engine to locomotive, Sun as pivotal to grand trine and t-square, Mars as focal planet in t-square, Mars as pivotal to yod and t-square

C1. 8 squares
2. no sextiles (unless Moon/Mars counted, in yod)
3. Venus conjunct descendant, 1 degree, 7 minutes
4. Mars square Pluto, 1 degree, 12 minutes
 Uranus square Moon, 1 minute
 Saturn square Venus, 1 degree, 12 minutes
 Sun trine Neptune, 1 degree, 29 minutes
5&6 *Ignore. Too many other considerations*
7. Venus/Uranus mutual reception (also in square)
8. North Node in Virgo at end of 1st house
 South Node in Pisces at end of 7th house
 Both square Jupiter, 2 degrees, 17 minutes.

D1. Sun, 7 counts (counting 4 for focal planet)
2. Aquarius, Capricorn and Taurus, 4 counts
3. 6th house emphasis, 5 counts
4. Moon in Aquarius square Uranus, 1 minute

F. *The Primary Characteristics:*
 Few charts are as strong as Muhammed Ali's. Even being particularly selective, we will want to focus on more than eight of its features.

 1. 10 fixed signs
 2. no water signs
 3. 6 retrograde planets
 4. t-square to Mars in Taurus in 9th house
 5. grand earth trine with 6½ earth signs
 6. Moon in Aquarius square Uranus, 1 minute

7. pivotal Sun in Capricorn in 6th house, as engine of locomotive pattern
8. Saturn in 10th near M.C.
9. Venus descending in mutual reception to Uranus

CHART B

Horoscope of Liza Minelli, 3/12/46, 7:58 a.m., P.S.T., Los Angeles, California. SOURCE: Horoscopes Here and Now.

A1. 6 water
2. 2 earth (ascendant and midheaven only)
3. 9 cardinal
4. 2 fixed (Pluto and ascendant only)
6. t-square to Mars conjunct Saturn and Moon in Cancer on I.C. We don't separate a close conjunction if one of its planets is technically within the orbs of the configuration and the others aren't.
7. Sun trine Moon, 2 degrees, 21 minutes
8. Taurus rising, Capricorn midheaven
9. 4 retrograde planets

B1. Sun in Pisces in 12th house
2. Moon in Cancer in 4th house
3. Neptune retrograde in Libra in 6th house
4. Venus in Aries in 12th house
5. Moon in Cancer
6. Moon in 4th house
9. Moon conjunct I.C., 13 minutes
Saturn conjunct I.C., 1 degree, 21 minutes
Mars conjunct I.C., 3 degrees, 15 minutes
12. Moon, sole dispositor
13. Saturn, Moon and Mars, 6 aspects (counting M.C. axis and extended orbs in t-square)
15. Mars, focal planet in t-square, linked by conjunction to Saturn and Moon

C1. 7 squares, with extended orbs in t-square
3. Mars conjunct Saturn, 1 degree, 54 minutes
Saturn conjunct Moon, 1 degree, 8 minutes
Moon conjunct I.C., 13 minutes

4. Mercury trine Pluto, 45 minutes
 Mercury opposition Neptune, 1 degree, 21 minutes
6. Pluto parallel Moon, reinforcing strong Moon
8. North Node in Gemini in 2nd house
 South Node in Sagittarius in 8th house
 North Node trine Jupiter, 2 minutes

D1. Moon extremely strong, 9 counts
 2. Cancer, 5 counts
 3. 12th house, 5 counts (Counting Moon as 4th house and
 Saturn and Mars each as ½ 4th and ½ 3rd, the 4th house
 still has only 4 counts.)
 4. Moon conjunct I.C., 13 minutes
 Mercury opposition Neptune, 1 degree, 21 minutes is
 closest square or opposition, but Moon/Saturn conjunc-
 tion, 1 degree, 8 minutes is stronger.

F. *The Primary Characteristics:*
 1. Moon in Cancer on I.C., own house, sole dispositor,
 closely conjunct Saturn
 2. 9 cardinal signs
 3. t-square to Mars conjunct Saturn and Moon
 4. Sun in Pisces in 12th house, 12th emphasis
 5. Sun trine Moon
 6. 6 water signs
 7. No planets in earth signs
 8. North Node in Gemini in 2nd house in exact trine to
 Jupiter

CHART C

*Horoscope of Charles Manson, 11/12/34, 4:40 p.m. E.S.T.,
Cincinnati, Ohio. SOURCE:* American Astrology.

A1. 6 water
 2. 1 fire (Uranus)
 3. 9 fixed
 4. 2 mutable
 5. seesaw
 6. cardinal/fixed grand cross
 loose Scorpio stellium in 7th house

 7. No Sun/Moon aspect but square by sign
 8. Taurus rising, Capricorn M.C.
 9. 2 retrograde planets

B1. Sun in Scorpio in 7th house
 2. Moon in Aquarius late in 10th house
 3. Pluto in Cancer retrograde in 4th house
 4. Venus in Scorpio in 7th house
 6. Venus in 7th house (Mercury is at the end of the 6th but has more influence upon the 7th.)
 10. Jupiter and Mercury within 3 degrees of the descendant
 11. Mercury stationary direct
 13. Moon, 6 aspects counting conjunction to N. Node
 15. pivotal Mercury linking stellium and cross

C1. 8 squares, counting ascendant but not nodes
 2. All major aspects represented, but sextiles and trines extremely weak
 3. Sun conjunct Venus, 1 degree, 31 minutes (This conjunction gives added weight to Venus.)
 Mars conjunct Neptune, 34 minutes
 Moon conjunct North Node, 2 minutes
 4. Mercury square Moon, 1 degree, 1 minute
 Moon square ascendant, 1 degree, 6 minutes
 5. Mars/Neptune are near midpoint of Pluto/Mercury square, semi-squaring both Pluto and Mercury.
 6. Sun/Venus and Mars/Neptune conjunctions are reinforced by parallels.
 7. No mutual receptions (Since Mars rules Aries, Mercury in Scorpio and Mars in Virgo are not in mutual reception.)
 8. North Node in Aquarius late in 10th house
 South Node in Leo late in 4th house
 North Node conjunct Moon, 2 minutes
 Nodes both square Mercury, 1 degree, 3 minutes
 Nodes both square ascendant, 1 degree, 4 minutes

D1. Mercury, 4 counts (Venus is 3 counts, but its conjunction to the Sun strengthens it.)
 2. Scorpio, 7 counts

3. 7th house, 7 counts (Mercury as ½ 6th, ½ 7th)
4. Moon conjunct North Node, 2 minutes or Mars conjunct Neptune, 34 minutes
Closest square: Mercury square Moon, 1 degree, 1 minute
E1. Descendant near Mercury/Jupiter midpoint
2. Last lunar eclipse: 2 Aquarius 48, conjunct Moon
F. *The Primary Characteristics:*
1. 9 fixed signs
2. 6 water signs
3. 1 fire sign
4. Scorpio stellium in 7th house, with Sun in Scorpio in 7th
5. cardinal/fixed grand cross
6. few trines and sextiles, all weak
7. seesaw pattern
8. Moon in Aquarius in 10th house conjunct North Node at previous lunar eclipse point, both squaring ascendant, Mercury and Jupiter

CHART D

Horoscope of Patty Hearst, 2/20/54, 6:01 p.m., P.S.T., San Francisco, California. SOURCE: American Astrology.

A1. 6 water signs
2. 1 earth sign (ascendant)
3. 7 mutable signs
5. weak splash (open square)
6. mutable t-square to Mercury and Venus in Pisces in 7th house. (The close Mars/Venus and Mercury/Jupiter squares bring it together.)
weak grand water trine
7. weak Sun inconjunct Moon
8. Virgo rising, Gemini midheaven
9. 5 retrograde planets
B1. Sun in Pisces, end of 6th house, influencing 7th
2. Moon in Libra, 2nd house
3. Neptune retrograde in Libra, 2nd house
4. Mercury retrograde in Pisces, 7th house

6. Uranus in 11th, Venus in 7th house
10. Venus 3 degrees after descendant
 Sun 2 degrees, 20 minutes before descendant
13. Venus, 6 aspects (extending orbs in t-square)
15. Mercury and Venus, focal planets in t-square

C1. 8 squares (extending orbs in t-square)
 3. Venus conjunct descendant, 3 degrees
 Sun conjunct descendant, 2 degrees, 20 minutes
 4. Jupiter square Mercury, 31 minutes
 Mars square Venus, 1 degree, 4 minutes
 5. Uranus semi-square ascendant, 16 minutes
 Pluto semi-square Moon, 14 minutes
 Venus inconjunct Moon, 1 degree, 7 minutes (strong
 2nd/7th connections)
 6. Sun/Venus parallel reinforces conjunction
 Jupiter/Uranus/Pluto parallel unites S.E. quadrant.
 7. Neptune in Libra mutual reception Venus in Pisces, link-
 ing 2nd and 7th houses
 8. North Node in Capricorn in 5th house
 South Node in Cancer in 11th house
 South Node conjunct Uranus, 3 degrees, 55 minutes
 Both nodes square Neptune, 2 degrees, 28 minutes

D1. Venus, 6 counts
 2. Pisces, 6 counts
 3. 7th house, 4½ counts (Sun as ½ 6th, ½ 7th.)
 4. Jupiter square Mercury, 31 minutes

F. *The Primary Characteristics:*

 1. 6 water signs and grand water trine
 2. 7 mutable signs
 3. 1 earth sign (ascendant)
 4. Venus in 7th house near descendant in mutual recep-
 tion to Neptune
 5. Sun in Pisces late 6th house inconjunct Moon in Libra
 in 2nd house
 6. mutable t-square to Mercury and Venus in Pisces in
 7th house

 7. Uranus in 11th house near South Node
 8. 5 retrograde planets

CHART E

*Horoscope of Liv Ullman, 12/16/38, Tokyo, Japan, rectified
for 7:10 p.m. SOURCES: The Mercury Hour and Astrology
Guide. (Both give 7:20 p.m.) [Name also spelled Ullmann.]*

A1. 6½ fire (ascendant as ½ Cancer, ½ Leo)
 2. 2 earth
 3. 5½ fixed (ascendant as ½ Cancer, ½ Leo)
 4. 4 mutable
 7. Sun sextile Moon, 45 minutes
 8. Cancer/Leo rising. Aries midheaven
 9. retrograde planets

B1. Sun in Sagittarius, 5th/6th cusp
 2. Moon in Libra, 4th house

B3. Jupiter in Aquarius, 8th house
 4. two rulers—Sun in Sagittarius on 5th/6th cusp and Moon
 in Libra in 4th house
 6. Moon in 4th house (Sun end of 5th.)
 7. Pluto rising, 1 degree, 18 minutes
 11. Saturn stationary direct
 13. Moon and Mercury, 5 aspects

C1. 6 squares
 3. Pluto conjunct ascendant, 1 degree, 18 minutes
 4. Sun sextile Moon, 45 minutes
 Sun square Neptune, 30 minutes
 5. two inconjuncts to Jupiter, but no yod
 6. Moon/Mars parallel brings them into conjunction.
 Uranus/Venus contraparallel reinforces the opposition
 between Uranus and Venus.
 Sun/Pluto contraparallel reinforces Pluto rising
 8. North Node in Scorpio late in 4th house
 South Node in Scorpio late in 10th house
 South Node conjunct Uranus, 1 degree, 18 minutes
 (North Node conjunct Venus, 4 degrees, 29 minutes)

D1. Moon, 4½ counts (counting Moon as ½ ruler of ascendant)

2. Sagittarius, 4 counts

3. 4th house, 4 counts (with 5th house as 3½ counts, counting Sun ½ 5th, ½ 6th)

4. Sun square Neptune, 30 minutes

E1. Last lunar eclipse 14 Taurus 53, conjunct Uranus

2. Saturn elevated (closest planet to midheaven)

F. *The Primary Characteristics:*

1. 6½ fire signs

2. Pluto rising

3. Sun in Sagittarius, 5th/6th cusp

4. Moon in Libra, own house

5. Sun sextile Moon, both rulers of Cancer/Leo ascendant

6. stationary direct Saturn in 9th house near midheaven

7. Sun square Neptune, 30 minutes

8. Uranus conjunct South Node in 10th house

8.

Example Interpretation
(Chart E)

The following interpretation of the outstanding features
of award-winning actress Liv Ullman's natal chart is supple-
mented by a commentary which provides illustrations from
her life, drawn primarily from her autobiography *Changing*,
but also from *Liv Ullman and Ingmar Bergman* by Bernie
Garfinkel.

6½ FIRE SIGNS

A count of 6½ fire signs indicates that Liv Ullman is an
energetic and self-motivated individual, enthusiastic and op-
timistic about life, and willing to plunge wholeheartedly into
new experiences. Highly subjective, she may have difficulty
distancing herself from her intense emotions, but she is never-
theless capable of expressing herself dramatically, directly
and creatively.

SUN IN SAGITTARIUS
ON THE 5th/6th HOUSE CUSP

Ullman's Sagittarian Sun is another indicator of her posi-
tive and outreaching approach to life. Her personal freedom is

important to her, and she desires to expand her awareness through travelling and through opening herself to new experiences. Direct and honest in her self-expression, she is forever philosophizing about the meaning she distills from her life circumstances, as she attempts to conceptualize and share with others the wisdom that she has discovered.

Because her Sun is near the end of the 5th house, it influences both the 5th and 6th houses of her chart. Its 5th house influence suggests a pronounced desire to develop her creative abilities as fully as possible, particularly to express her creativity and intuition in meaningful, inspiring ways, true to the nature of Sagittarius. Capable of being both entertaining and profoundly philosophical, she enjoys being center stage and giving generously of herself to people who appreciate her openness, her insight and her talents. This 5th house influence also indicates Ullman's willingness to open herself to new romantic involvements, taking emotional risks in love affairs with men who will not threaten her desire for freedom and continued personal growth. Her understanding of life is deepened through her romantic experiences, and also through her relationships with children. Her own child brings out the playful, untrammeled spirit in her; with Lin, she gives of herself freely, eager to help Lin develop herself and understand her experiences.

The 6th house influence of Ullman's Sagittarian Sun indicates a desire for a work situation which allows her considerable freedom, so that she may express herself according to her own inner direction. She enjoys work which allows her to travel, expanding her contacts with new people and places. Although she adores the limelight, she is also capable of functioning in a subordinate role, fulfilling what she regards as her duties conscientiously and enthusiastically. Because the 6th house is also the house of health and Ullman's Sun is co-ruler of her ascendant, she is highly aware of her physical body, and cares for herself by eating heartily and taking many long walks in the country.

This combined 5th/6th house Sun actually establishes a connection between these two areas of Ullman's life. Her

leisure time is minimal because of the demands of her work; her work involves dramatic creative expression. In her relationships with men and with her own child, she is extremely aware of her responsibilities and obligations, and desires to be a helpful, readily available companion.

COMMENTARY: *The above interpretation is validated by Ullman's autobiography, in which she expresses herself honestly and reflectively, sharing not only the circumstances of her professional life on stage and in films, but also her understanding of her marriage with Jappe and her five years with Ingmar Bergman. Her Sagittarian Sun is fully evident when she says of her theatrical performances, "I look forward to the sense of freedom that comes in the silence and the laughter from the audience much more than in the applause afterwards." Philosophizing further, she adds, "How good it is to have a life that gives so much freedom, so many choices. I can be free by my own will, be my own creator and guide. My growth and my development depend upon what I choose or discard in life. In me are the seed of future life."*

SUN SQUARE NEPTUNE

As the most exact aspect in her chart, the square between her Sun and Neptune entering the 3rd house indicates that Ullman experiences considerable insecurity and self-doubt. During her early years, she would have bolstered her ego in a passive way, fantasizing about future successes and future romantic relationships. Because of this square, the adult Ullman may be still inclined to escape from pressures and feelings of inadequacy by fantasizing and by running away—in a 3rd house manner, through reading, taking short trips and interacting with a variety of people, and in a 5th/6th house manner, by immersing herself in her creative work.

This square also indicates a weak father figure, or one who was not fully there for her when she was young. Because her relationship with him was based on fantasy, she is inclined to deceive herself in adult relationships with men, falling in love with her own romantic expectations and then becoming dis-

illusioned when her idol falls off his pedestal. Nevertheless, Ullman is quite sensitive to the needs of the people around her. Her own ideals in regard to her behavior are so high that she feels guilty if she can not always be loving, compassionate and responsive.

One of the positive dimensions of Ullman's Sun square Neptune is that it motivates her to express her fantasy and idealism outwardly, fulfilling her Sun's desire for self-expression through the Neptunian means of the creative arts. Neptune may indicate oversensitivity, but is also suggests a highly developed imagination and deep feelings of empathy and compassion. Not only can Liv respond sensitively to other people's feelings, but she can also use her empathy in her acting, immersing herself fully in the emotional experiences of the characters she plays.

COMMENTARY: *Ullman's father died when she was six; she idealized him, and used to fantasize constantly about strange men being her father and handsome princes carrying her off in the night. When she first married, she regarded her husband as her savior and protector; when he failed to fulfill her expectations, she turned to Bergman, believing him to be God, making possible for her a dreamlike life on a deserted island. These two important men in her life were very Neptunian—one a psychiatrist, and the other a film director.*

One of the themes of Ullman's autobiography is her oversensitivity to the people she loved. "I see myself as a sieve. Everyone's feelings flow through me," she wrote. Torn with guilt at not being able to respond always to both her daughter and to Bergman, she wrote, "I rushed from one to another, always with a bad conscience, never able to completely give what I yearned to receive."

Although Ullman's early years were characterized by shyness, self-doubt and feelings of failure, she was able to channel her creativity into theatrical writing, acting and directing when she was still a schoolgirl; by the age of 20, she had begun her professional career as an actress. Ullman is an outstanding example of a woman who has, despite her confusion, used her

Sun square Neptune constructively. The emotional chaos of her first love relationships became a rich source for her to draw upon in her dramatic roles. ("I wonder if I am having a nervous breakdown," she once wrote. "And if so, can I give it artistic expression?") The disillusionment she experienced in love deepened her understanding of herself and led her to develop and express her own identity as an inspiring and talented woman. "I was brought up to be the person others wanted me to be, so that they would like me and not be bothered by my presence," Ullman wrote in Changing. *"When I began to be me, I felt that I had more to give."*

MOON IN LIBRA IN THE 4th HOUSE

Ullman's Moon in Libra in its own house is very strongly placed; its Libran influence indicates that she has a powerful need to form close personal relationships, but tends to become emotionally dependent upon a partner who can provide the security which she craves. Quite likeable, charming and considerate, Ullman wants very much to please and to be liked. Because discord in personal relationships is very upsetting to her, she has, at least in the past, attempted to insure harmony by fulfilling other people's expectations. But placing other people's happiness before her own has left her unsatisfied and indecisive about what she wants. Fortunately, the Moon in Libra also indicates that she turns inward when her own equilibrium is threatened, and that she strives to achieve peace and balance within herself as well as in her relationships.

The 4th house placement of Ullman's Moon suggests close ties with her mother, and an urge to function in a mothering role herself within a domestic setting. It also indicates a quite insistent yearning to be mothered by someone who will protect her and respond to her emotional needs. Ullman lives in her feelings; they dominate her awareness, contributing to her sense of inner restlessness, but also grounding her and providing the psychological fuel which enables her to find fulfillment in many areas of her life. Because she is also deeply attached to her home and is most secure there, Ullman desires to retreat from the world frequently, hiding within an idyllic

refuge where she can commune quietly with herself and her loved ones.

COMMENTARY: *When she was a child in a one-parent home, the central figures of Ullman's life were women—her mother and her grandmother. When she married, she expected her husband to mother her also. "I was dependent and happy that he was the stronger and wished to look after me," she wrote about Jappe. Even when she left him for Bergman, Ullman said, "I sought the absolute security, protection. A great need to belong." With Bergman, Ullman hoped to establish a domestic paradise. The barrenness of the island on which they lived disturbed her, but here she could lose herself completely in their togetherness. "Nothing existed outside ourselves," she wrote of this time. And yet she was lonely, longing for more human contact than Bergman could offer.*

When Ullman travelled, she was frequently homesick. Upon returning, she usually plunged enthusiastically into domestic life, seeking peace of mind. All too often, the ringing phone brought more responsibilities and obligations, which led her to exclaim repeatedly, "Where on earth can I go to be left in peace?"

Ullman's love for her daughter Lin permeates her autobiography, but so does her guilt that she is being an inadequate mother, and her insecurity at displeasing the people of her home town who expected her to devote herself totally to her family. Their reactions to her, as well as those of her first husband and Bergman influenced her deeply. "I have spent hours completely involved in what I thought other people wished to see me doing," she says of herself. "The fear of hurting, fear of authority, the need for love have put me in the most hopeless situations. I have suppressed my own desires and wishes, and ever eager to please, have done what I thought was expected of me." Yet Ullman also reveals that soon after Bergman and she separated, she began to turn to herself rather than look for a protector. Fully aware of her own feelings and her own power, she experienced inner security and peace.

SUN SEXTILE MOON, CANCER/LEO ASCENDANT

The sextile between the Sun in Sagittarius and the Moon in Libra in Ullman's chart is particularly significant because her ascendant, on the Cancer/Leo cusp, is ruled by both the Sun and the Moon. This sextile indicates that Ullman is attuned to her feelings and able to express them in a spontaneous and free-flowing manner. Her emotional energy and high vitality contribute to her ability to invest herself fully in her experiences and to make productive use of her creative talents.

Because she enjoys expressing herself and gaining new insights, Ullman finds her life quite fulfilling. A harmonious relationship between her parents helped her to develop a positive attitude toward men and toward family life in general; as a result, she is able to open herself emotionally to the people that she loves, responding sensitively to them and allowing herself to be nourished by their love for her. The Libra/Sagittarius link between the Sun and Moon denotes a blend of honesty and diplomacy in her personal relationships, as well as a desire to give of herself generously and to expand her understanding of human dynamics.

Normally, a sextile between the Sun and Moon indicate self-acceptance and self-confidence. However, these attributes are somewhat weakened in Ullman's case by her close Sun/Neptune square which, as noted before, suggests insecurity resulting from her oversensitivity to other people's feelings and her inability to live up to her own impossible ideals.

Another connection established by Ullman's Cancer/Leo ascendant and Sun/Moon sextile is the link between her 4th, 5th and 6th houses. This enables her to draw from her deepest feelings and from the circumstances of her personal life in the roles that she plays as an actress, and to fulfill many of her emotional needs through her creative work.

The Moon ruling Ullman's ascendant contributes to her soft, often gentle appearance and the sensitive manner in which she expresses herself. Yet as the Sun bursts through her Cancerian timidity, she becomes dynamic and radiantly self-expressive.

COMMENTARY: *The above interpretation is also validated by Ullman's autobiography. Although her father died when she was six, she did view her parents' relationship as harmonious. Her own marriage, which didn't last, was nonetheless pleasant, and neither it nor her five year affair with Bergman soured her attitudes toward men.*

Ullman's Libran/Sagittarian blend is evident in her honest reflections about herself and her relationships. While she decries the artificiality of Hollywood people, she nevertheless is hesitant to reveal the dark secrets of the people she has known, and she even admits, upon viewing a woman speak too truthfully about her husband on television, that "there are so many situations where being honest is exactly the wrong thing to do."

But what of Leo bursting through the Cancer of Ullman's ascendant? "I can never completely hide who I am, what I am," she says as she reveals the depths of her feelings. And then in one statement she sums up her 4th house Libran Moon and Sagittarian Sun, "I want to be in somebody's pocket, to be taken care of. But then I want to be free too."

RETROGRADE PLUTO RISING

Naturally, Ullman's Cancer/Leo ascendant is influenced by Pluto, barely a degree away. Because it is retrograde, Ullman does not experience or express Pluto's overt characteristics, such as an overriding need for power, as much as she experiences and expresses Pluto's psychological, subjective side. She desires to plumb her inner depths, to remain in touch with the raw and intense emotions which reside there, and to continually deepen and transform her self-awareness by coping with the numerous crises of her life and by regenerating herself through them.

Ullman is an intense and passionate person, aware of her inner power and of the turbulent emotions churning inside her, demanding to be released. Her life is a continual process of psychological deaths and rebirths. She is also aware of the harsh reality of physical death, which she confronted quite

traumatically when very young. Because of the turmoil she experienced then, Ullman turned inward at an early age, developing an emotional life which was both richer and more painful than that of her childhood companions; as a result, she felt quite isolated, unable to share her experiences or enjoy the simplicity and superficiality of most childhood pastimes.

As open as she is, the adult Ullman carries inside her a private life forged in her earliest years, which she may hesitate to reveal in all its intensity. Its hold upon her may contribute to her feelings of isolation as an adult, because so few of the people around her are capable of experiencing or relating to the demonic yet healing forces of the subconscious. Fortunately, however, Ullman's Pluto rules her 5th house, enabling her to channel her turbulent Plutonic energies into romantic/sexual relationships and into the dramatic and psychological roles which she plays as an actress. Pluto is retrograde in Ullman's chart, but even a retrograde Pluto is a powerful one, suggesting that Ullman develop her will on the deepest levels and mobilize all of her energies to fulfill her desires and regenerate herself.

COMMENTARY: *The themes of self-awareness and self-transformation, loneliness and death permeate Ullman's autobiography. "I am constantly living in a state of change, although deep inside I am 'a young girl who refuses to die,'" she writes about herself, and later adds, "All the time I am trying to change myself. . . to find peace, so that I can sit and listen to what is inside me without influence." Of her own gentle appearance, she says, "It is astonishing that so much anger can be contained behind such a mild facade."*

Throughout her book, Ullman reveals how deeply her childhood experiences have shaped her. "I will never forget," she recalls painfully, "the loneliness I knew as a child. . . . For me, the sense of isolation was the traumatic experience. . . . I have grown up and at times still feel the outsider, believing that everyone else is part of some togetherness." About her father's death, which was followed closely by the deaths of her grandmother and nurse, Ullman reflects, "That cut into me

so deeply that many of life's experiences relate to it. The void Papa's death left in me became a kind of cavity, into which later experiences were to be laid." Ullman admits that she feels limited by her own fear of death, and describes how some of the intense roles which she played as an actress—roles which Bergman actually developed with her in mind—forced her to confront the reality of her own death.

Changing *is a book of self-exploration, a confessional and yet not a confessional because Ullman retains a dignity and privacy beneath her openness. She prefers not to expose any lurid secrets or to divulge any intimate details about her sexual life. Her retrograde Pluto indicates a natural reticence and self-control, but does not by any means silence her desire to express herself.*

SATURN STATIONARY IN
ARIES LATE IN THE 9th HOUSE

Ullman's stationary Saturn in Aries also enables her to "put the brakes on" her self-expression, as well as to successfully control her emotional and physical energy, channeling it into the dramatic roles which require her total involvement and concentration. Its stationary position can result at times in an obsession with her career, as well as in a tendency to get stuck repeatedly in the same kinds of work issues, roles or behaviors.

Because it is in the 9th house, Ullman has a quite rigorous sense of ethics, which contributes to the guilt she feels when she does not live up to her own expectations. She also takes her beliefs quite seriously and attempts to clarify her understanding in a systematic way so that she may clearly grasp the meaning underlying her experiences. This position, accentuated by its closeness to the M. C., suggests her willingness to apply herself to education or training related to her professional goals, and a desire for a career which furthers her own personal development and enables her to travel or make long distance contacts. She does not, however, easily relax or feel at home in foreign environments.

Because her Saturn is stationary, Ullman is at times obsessed with her father or with men who become father figures to her. Her relationship with her own father would have influenced her philosophical approach to life and her quest for understanding.

COMMENTARY: *Many of Ullman's previously-mentioned perceptions and experiences support the above interpretation. Her father's death resulted in her turning inward at an early age, seeking meaning in her life; her most important relationships with men were with Jappe and Bergman, who were considerably older than her and were, to some extent, father figures.*

Ullman attended acting school in order to prepare herself for her career, which has involved much travel and contact with new people. Although she enjoys travelling, she admits that she is shy with strangers, frequently homesick, and does not adapt well to new environments. Because her work is so important to her, Ullman frequently chooses professional commitments over domestic joys and responsibilities, and says of herself, "What I need from a man is that . . . he should know that it is as a working woman that I am happy and can make him happy."

Although Ullman did flaunt conventional morality by living with Bergman for 5 years and bearing his child, she does have a strong sense of personal morality, evident in her unwillingness to appear nude in films, and in her guilt at not being the dedicated mother or at not always knowing her lines. "My guilt is deep-seated," she says. "Bad conscience is part of my everyday life."

SOUTH NODE IN TAURUS CONJUNCT URANUS RETROGRADE LATE IN THE 10th HOUSE

Ullman's nodal placements summarize many of the important characteristics in her chart. The South Node in Taurus in the 10th house suggests that she feels pulled toward earning her income and maintaining her self-worth through developing her professional resources. The conjunction to retrograde

Uranus suggests a natural ease in following her own intuition, in remaining aware of and coping with change, and in being an independent individual, freely creating her own unique lifestyle. Uranus' retrograde placement both enhances her psychological understanding and increases her inner restlessness; it does not, like a direct Uranus in the 10th house, incline her to exhibit herself in a highly unconventional or radical manner.

Because of the combined influence of the South Node and Uranus in Ullman's 10th house, she is capable of acting with a minimal amount of direction, relying on her own intuition and psychological insight to create deeply revealing portrayals of character. She also thrives on changes of pace in her career and develops many professional friendships.

Ullman's North Node in Scorpio in the 4th house indicates that she should be confronting the deepest issues of her personal life and expressing her perceptiveness and healing, transforming influence in her home, rather than merely channelling her emotional intensity into her acting. She needs to build a base, a security on an inner level which will enable her to regenerate herself and find adequate outlets for her pent-up emotions. Using her South Node to fulfill the purpose of her North Node, Ullman can benefit by drawing upon the resources she has developed professionally—her income, her sense of security, her artistic talents, her psychological understanding—to build more enduring home and family ties, and to strengthen her own inner foundations.

COMMENTARY: *Again, the Ullman revealed so far substantiates her nodal placements. The South Node conjunction to Uranus is particularly evident. She has experienced herself as an outsider, living an alternative lifestyle, even to the point of inviting scandal because of her relationship with Bergman, who has been lover, director and friend. She acknowledges that her intuition has always been her strong point in her acting, and she most frequently plays psychological roles which allow her to freely draw upon her own insight and experience. In her autobiography, aptly entitled* Changing, *she expresses*

again and again how she thrives on the unpredictabilities of her life. "Is this not where life's possibilities lie? Not necessarily to arrive, but always to be on the way, in movement," she writes.

But does Ullman express her 4th house North Node sufficiently? Yes and no. *Curiously enough, many of her movies and plays have had 4th house titles and themes, focusing on intense domestic struggles or closeness to the land*—A Doll's House, The New Land, The Emigrants, Scenes From A Marriage, Autumn Sonata. *While she says, "the private life must be the most important," Ullman nevertheless does find that the pull of her professional life often overpowers her desire for a fully satisfying home life. Yet at the same time, she does not allow herself to be become overly dependent upon the limelight and she does not regard her professional success as her primary source of security. She is coming to terms with her nodal axis, is groping to remain in touch with her deepest self, with her inner center. Aware of how she used to give her power away both professionally and personally, she is able, as she completes* Changing, *to state with conviction, "The only real safety in the world is the safety I feel in myself."*

PART THREE

THE PROCESS
OF ASTROLOGICAL
COUNSELING &
INTERPRETATION

9.

Astrology as a Counseling Tool

Knowing how to synthesize and interpret a chart is a pre-requisite for becoming an astrologer. But your knowledge alone is not sufficient for you to effectively impart what you know in a manner which benefits others and which responds to their needs. Whether you do brief interpretations for friends, or are beginning to charge fees to clients for astrolog-ical consultations, you are using your astrological understand-ing as a counseling tool to influence other people's lives, and you have a moral responsibility to develop your awareness of the counseling process and your counseling skills.

This book does not pretend to train you as a counselor. Any astrology student planning to use astrology directly with people is advised to enroll in one or more counseling courses, to read books on the counseling process itself, and to gain experiential supervised practice with counseling skills. Only one small facet of counseling involves interpretation and imparting information—the two domains which are usually the focus of astrological work. But even if you define yourself

as an astrologer or interpreter rather than an astrological coun-
selor, you are still exposing yourself to situations in which
other people are turning to you for help with stated or un-
stated needs. Because of their needs, and because of the potent
archetypal impact of astrological symbols, you are likely to
have a significant influence upon their conceptions of them-
selves and their attitudes toward their lives. For this reason,
you have an ethical obligation to be sensitive to the nuances
of your interpersonal interaction.

In this section of this book, we will therefore address some
of the basic issues with which you may struggle as you attempt
to utilize astrology interpersonally. What are your aims in
conducting a consultation? What qualities do you need to de-
velop and express as an astrologer and counselor? How is an
astrologer similar to and different from a non-astrological
counselor, and to what extent do you personally choose to
maximize your counseling, as distinct from astrological skills?
What psychological characteristics and problems are likely to
interfere with your responsible functioning in this role?

After addressing these preliminary issues, we will consider
such facets of the astrological counseling process as: beginning
the astrologer/client relationship, the constructive use of inter-
pretation and advice-giving, and the use of counseling interven-
tions which can help deepen and facilitate the integration of
astrological material. The final chapter of this book again re-
turns to content rather than process and demonstrates the
application of psychological insight to the interpretation of
the signs.

THE AIMS OF THE ASTROLOGER

First, let us consider the aims of the astrologer. Most of us,
as astrology students and astrologers, share most of the follow-
ing aims:

1) We wish to help our client/friend clarify and gain a realistic
self-image, which involves an accurate assessment of her
strengths and potential as well as areas of weakness and con-
flict. Such an assessment may involve a redefinition of the self,

a relinquishing of illusions in regard to both positive and negative tendencies.

2) We wish to enable our client/friend to increase her self-acceptance, to appreciate her individuality and uniqueness, and to therefore be able to conceptually hold her difficulties in a more affirming manner.

3) We wish to confirm and therefore support our client's sense of self and sense of reality, particularly insofar as astrological interpretation confirms these perceptions and translates what may have been vague intimations into clearly defined language.

4) We wish to help our client develop a more viable philosophy of life, or a belief system which makes sense to her, gives meaning to suffering, imparts a sense of purpose, and provides guidance for more effective living. Developing such a belief system, along with the overall perspective which astrology can provide, may involve challenging false, outdated or destructive assumptions and beliefs transmitted by parents and society.

5) We wish to support our client in her attempt to gain understanding and choose paths of action which will help her to progress and overcome her primary life difficulties. As she gains more objectivity and clarity in regard to her conflicts, she becomes more capable of surmounting them.

6) We wish to help our client empower herself, not only to expand her awareness of options and alternatives, but also to build the hope, faith, courage and motivation necessary to take more active responsibility for her life.

7) We wish, particularly in our use of transits and progressions, to impart to our client an understanding of cycles, and a long-range perspective on her patterns, challenges and opportunities, so that she may develop not only patience and a sense of order, but also an appropriate sense of timing in regard to action.

How are we likely to meet these aims, or at least to plant the seeds by which these aims can begin to take root within an astrological consultation? Developing such expertise is

WE CAN USE ASTROLOGY IN A VARIETY OF WAYS:

as a crutch:

"Beware the Woman, too, and shun her Sight
Who, in these Studies, does her self Delight,
By whom a greasy Almanack is born,
With often handling like chaste Amber, worn;
. . . She if the Scheme a fatal Journey show,
Stays safe at Home, but lets her Husband go.
If but a Mile she Travel out of Town
The Planetary House must first by known."

from *The Sixth Satire*
by Juvenal

as an instrument of fear. . . or of faith:

"Any possibility can become either a positive or a negative
actuality. FEAR tends to make of it a negative manifesta-
tion; FAITH turns it into a positive fact. The central
problem. . . is therefore the transmutation of fear into
faith. Astrologically speaking, this means acquiring a
constructive attitude to one's 'bad' aspects."

from *Astrology and the Modern Psyche*
by Dane Rudhyar

"Will the astrologer only crystallize and focalize fear by
his forecasts; will he extend the scope of his client's
confusion and sense of disorder—or will he be able to
give to him, who, consciously or subconsciously yearns
for guidance into a new realm of order the faith that this
new realm exists and can be reached?"

from *The Practice of Astrology*
by Dane Rudhyar

as an exercise in intelligence and intuition:

"The interpretation of symbols demands intelligence. It
cannot be turned into a mechanical system and then
crammed into unimaginative brains. It demands an increas-
ing self-awareness on the part of the interpreter. . . One
may follow all the right rules and yet get bogged down in
the most appalling nonsense, simply by overlooking a

seemingly unimportant detail that a better intelligence would not have missed. Even a man of high intellect can go badly astray for a lack of intuition or feeling."

from *Man and His Symbols*
by C. G. Jung

as a channel of divine energies:

"Ye are part and parcel of a universal consciousness or God—and thus all that is within the universal conscious-ness, or the universal awareness; as the stars, the planets, the sun, the moon. Do ye rule them or they rule thee? They were made for thy own use, as an individual.

"Astrology is a fact, in most instances. But astrological aspects are but signs, symbols. No influence is of greater value or of greater help than the will of the individual.

"Use such directions [from the planets] as stepping stones. Do not let them become stumbling stones in thy exper-ience."

Edgar Cayce
from *Astrology and the Edgar Cayce Readings*
by Margaret H. Gammon

"The astrologer is a priest in the temple of the cosmos; he speaks for the old gods who reside in the farthermost and the innermost. It is his duty to teach as well as to delineate. The surest way to re-establish the dignity of the science of astrology is to challenge the astrologers themselves. They must realize that it is not enough to delineate charts according to the opinions of diversified authors. The astrologer must practice his science from deep and beautiful convictions within himself. He must realize his responsibility not only to his client but to the great assembly of the stars to which he has dedicated himself as a servant in their house."

from *The Philosophy of Astrology*
by Manly Palmer Hall

certainly a matter of understanding and practice, as well as clear intention. Holding these aims within ourselves and reminding ourselves of them continually may enable us to speak and act in a manner which is in keeping with them. However, we may also need to translate them into more concrete terms. We may wish therefore to ask: what qualities or characteristics do we need to possess, and what specific forms of behavior would enable us, as astrologers, to best impart these aims?

QUALITIES OF AN EFFECTIVE ASTROLOGER

1) An effective astrologer is able to perceive and respond to the actual and immediate needs of the client, not merely her own intellectual preconceptions.

2) An effective astrologer relates to the client first and the chart second. The chart is a means to an end, not the end itself.

3) An effective astrologer communicates acceptance, respect for the client's needs and sensitivities, as well as hope and encouragement.

4) An effective astrologer speaks clearly and concretely in a language which the client can understand. She is able to translate astrological symbols into concepts and specific examples which the client, in her life situation, can utilize.

5) An effective astrologer helps to discover or create clarity and order in the midst of chaos, by helping the client to focus upon key issues rather than become lost in peripheral concerns, and by helping to clarify the problems which exist and the alternative understandings and actions available.

6) An effective astrologer imparts a constructive philosophy which gives meaning to suffering and provides an organizing principle in the face of uncertainty and confusion. Such a philosophy involves the long-term perspective which results from the understanding of patterns and cycles. It also requires the astrologer to view immediate issues through the lens of perceiving the overall pattern.

7) An effective astrologer allows the client's needs to predominate over her own needs, and therefore lets the locus of con-

trol reside with the client. Such an attitude requires respect for the client's feelings in the moment, and for her capacity to understand and integrate the material presented so that she is not overloaded with more information than she can assimilate. Such an attitude also encourages the client to make her own choices and take action, rather than indicate that the astrologer has all the answers and all the power. Interest in and respect for the client's needs and feelings also requires that the astrologer ask questions, elicit information, give feedback and support, and otherwise engage in real dialogue, rather than serve merely as an imparter of information.

How are these qualities and actions similar to or different from those of a non-astrological counselor? Because systems of counseling and personality styles in counselors vary considerably, no simple answer exists. However, certain qualities are primary for an effective non-astrological counselor, which may be only secondary for an astrologer. Usually, a counselor maximizes her empathic abilities and is more concerned with facilitating the client's understanding and expression of feeling than in imparting her own beliefs of a recognized system of thought. She encourages emotional expression, listens carefully and perceptively, and reflects back her understanding of the client's communication. Rather than directing the session according to her own agenda, she allows the client to determine the movement, structure and purpose of the session. Most counselors do less than 20% of the talking in a session; taking a backstage position, they provide the environment and safety for a client to express herself and discover from within herself her own feelings, patterns, needs and alternatives.

Most clients who consult a counselor or a psychotherapist (who works more intensively and psychodynamically) establish a close relationship based on weekly sessions for a time period ranging from three months to ten years. Counselors do not expect significant insight or change to occur after only one or two sessions. Beginning astrologers who are hoping to have a dramatic impact upon the life situations of their clients may need to develop respect for the slow and intensive process by which real change occurs.

Astrological interpretation is not counseling in the true sense of the word. To what extent you wish to develop and utilize your specific counseling capabilities, such as your listening, reflecting and facilitating skills, is a matter of individual choice. However, for your astrological session to be more than a "head trip" for the client, to have a constructive impact, with the power and focus to mobilize new attitudes and actions, you will need to learn and make use of at least rudimentary communication and counseling skills. An assessment of your own capabilities based on personal awareness and astrological understanding may help you to determine your weaknesses and, therefore, the capacities you wish to develop. Are you a fire and air person with a lack of water, tending to ignore the feeling realm and unintentionally treading upon the sensitivities of a Pisces or Cancer person? Do you, as your Mercury opposition Neptune confirms, tend to communicate in vague, esoteric and roundabout generalities, and need to learn to concretize and ground your thinking process so that you can help an earth person who is preoccupied with practical decision-making? An effective astrologer, like an effective counselor, is flexible, and able to vary her style and communications in accordance with the temperament and needs of the individual client.

THE ASTROLOGER'S
PROBLEM AREAS AS A COUNSELOR

Conducting an astrology session is a demanding task, not only in terms of the knowledge required to interpret and synthesize a chart, but also because of the interpersonal responsibility. Lacking rigorous and sustained training in psychological systems, counseling skills and counseling ethics, many astrologers allow their own conscious and unconscious needs and problems to intrude upon the client. No counseling professional, whether psychotherapist, social worker or mental health counselor, is completely able to overcome such tendencies; we are all human and are all influenced by our blind spots, complexes, compulsions and unresolved emotional issues of the past. However, in order to be as responsible and

helpful as we can be, we need to develop the courage to confront ourselves, accurately assess our limitations, and apply ourselves to overcoming those which clearly interfere with our aims and responsibilities.

The following questions, presented in another form and discussed in more detail in *The Astrology of Self-Discovery*, are meant to serve as guidelines in helping you to pinpoint and clarify some of the problems which may interfere with your competence and constructiveness as an astrological counselor. Even if you are just beginning to interpret charts and are tentatively presenting your brief interpretations to friends, you may want to answer these questions and clarify the attitudes and behaviors which are currently influencing you. Most astrologers, after their first year of consultations, develop habitual methods of interpreting and counseling which are difficult to change. The more conscious you are of your style and process as you begin, and the more intention you develop in regard to your aims, the more likely you are to evolve a style of counseling and interpretation which will serve you for many years.

1) Do you experience yourself as superior to your client, by virtue of your knowledge, understanding and/or lifestyle? Do you express yourself as a know-it-all, a guru with all of the answers, using the astrological chart as an authority to mask your own need for power and authority, and your own lack of respect for or devaluation of your client's understanding, needs, feelings and life experience?

2) Do you, because of your urge to be needed or to have value as a helper, encourage the dependency of your clients? Do you prefer that they rely upon your advice, rather than turn to themselves and learn to trust their own guidance? Do you, because of your urge to please others, give clients and friends what they appear to want rather than what they may actually need?

3) Does your desire for attention lead you to do all the talking in a session? Do you show off your expertise rather than tune into the needs of the other person and continually assess whether you are responding to them? Are you

able to maintain an illusion of your considerable helping capacity by hearing only your own voice, empowered with the authority of astrological archetypes, rather than eliciting feedback and being willing to enter into the realities of your client's world?

4) Are you intent upon imparting truth as you conceive it, and therefore intruding your own philosophy upon your clients? Do you pass off your own ideas and values under the cloak of astrological authority?

5) Does your own sense of powerlessness, your own dependence upon planetary guidance and your own lack of trust in your own resources apart from astrological knowledge lead you to disempower your clients, imparting deterministic attitudes rather than actively encouraging and mobilizing their own will and trust in themselves? Do your negativities and fears regarding certain planets and signs influence your interpretation and result in your imparting pronouncements which could become destructively self-fulfilling prophecies? (If so, see worksheet on following page.)

6) Does your lack of real emotional self-awareness, as distinct from intellectual understanding, lead you to project your own conflicts onto your clients, so that you encounter your own shadow in the session, rather than the actual person in front of you? (If so, see worksheet on following page.)

7) Are you emotionally disconnected, out of touch with your feelings and other people's feelings, and therefore inclined to overvalue the mind and to intellectualize? Are you unable to impart understanding in a manner which is connected to emotion, or which facilitates the gut-level insight capable of being translated into action?

8) Do you speak in astrological jargon which your client can't understand, using language of mystical authority to create the illusion that you are imparting high truths, when indeed you may be saying little of significance? Do you

speak in vague, ungrounded generalities, avoiding addressing the real here-and-now concrete issues with which your client struggles?

9) Are you a victim of information compulsion, driven to feed your mind and other people's minds without regard for the capacities of assimilation, integration and application to everyday living? Are you more concerned with revealing how much you know and covering all the facets of the chart than you are with really using astrology to help your client?

Most professional astrologers are guilty on occasion of at least several of the above inadequacies, because of their personality dynamics and unresolved conflicts. The more courageously you are willing to confront and mobilize your resources to improve yourself in those areas in which you are deficient, the more likely you are to increase your self-respect, confidence and efficacy as an astrological counselor.

ASTROLOGY AND YOUR SHADOW: OVERCOMING FEAR AND NEGATIVITY

1. What planetary positions, aspects, etc., do you view as negative in your own chart (or in regard to transits)? Which ones are difficult for you to appreciate? How and why?

2. List at least three constructive attitudes that you might develop in regard to each of these planets or aspects. You might want to reflect upon what you've learned from them, how you've grown as a result of them, and what hidden strengths lie buried within the conflicts you've experienced.

3. What planetary positions, signs, etc., in the charts of others elicit negative reactions in you? Which "push your buttons" easily? How and why? How do you usually respond?

4. How is this planet/sign/aspect a part of you? How and why do you disown it in yourself? What is the result? (Repeat "I am such and such a way" in order to get in touch with how this quality may be a part of you and what feelings it stirs up for you.)

5. What would help you to accept this part of yourself more fully? How can you give it room to unfold, so that its more positive characteristics can grow and uproot the negative ones?

6. What is the positive quality hidden within this part of you? List some of its advantages and the attitudes which you might take to make peace with this quality within yourself.

7. What attitudes might you hold and what actions might you take in order to accept this quality more fully in other people? How might you be aware of your negativity/conflicts in regard to this quality, and alter your responses to it, so that it does not intrude upon your counseling?

10.

The Astrological Counseling Process

Every astrologer has a different method of conducting a session. Each of us has a unique personality dynamic, communication style, and skills or talents which we choose to maximize. For this reason, no clear and absolute guidelines can be presented in regard to the interpersonal dimension of astrological counseling. You will in time evolve your own style in accordance with your own nature. The suggestions presented in this chapter therefore should be adapted to your own situation.*

*Bear in mind that I am a Libra (aware of many alternatives, striving for synthesis, and concerned with the other person's responses) with Sagittarius rising and a ninth house Virgo stellium (both highly analytical and philosophical, aiming to develop practical and constructive guidance) as well as an Aries Moon (tending to respond spontaneously and often personally in the moment, regardless of whatever theories and plans I have been espousing). My astrological chart clearly influences my own behaviors and preferences in regard to conducting a session, just as your own planetary influences are likely to influence and guide you.

THE ASTROLOGICAL SESSION

My own procedure, when people first call me to express interest in having a consultation, is to begin by asking them their experience with astrology and their specific aims for a session. Why do they want an appointment, and why now? What issues and problems are they currently addressing? What is their fantasy in regard to what astrology can do for them? I also ask a few questions concerning the context of their lives— age, occupation, relationship status, and primary concerns in the present and immediate future.

At this point, I describe my own philosophy and use of astrology and, if appropriate, my training and experience. I then explain the details of my consultation policies—that I conduct three kinds of sessions (in addition to a private practice as a counselor/therapist): 1) natal, 2) transits and progressions, and 3) special interest (an intensive focus, involving natal and transits pertaining to one theme, such as love relationships), and that I usually require a natal session first. I make clear my fees, indicating my desire for a 50% deposit a week in advance, and my cancellation policy; I discuss my scheduling possibilities, usually based upon 90 minute tape-recorded sessions. Once we have agreed upon the time for a session, I record in my client record book (where I have already recorded the other information they have been imparting to me) their name, address, telephone and birth data. In order to insure accuracy, I always repeat back to them the birth data they have told me, asking them about the source of their data and whether they know for sure that their recorded time is daylight or standard time. The conversation usually ends with a confirmation of time and fee, directions to my office, and a reminder to bring a 90 minute cassette tape. Often, I suggest that if they have any more background information or questions that they would like to share before I do preliminary work on their chart, that they enclose a note when they mail their deposit to me. This initial conversation will indeed vary, and perhaps even be unnecessary if the client is a friend or acquaintance rather than a stranger. After this pre-

session telephone conversation, I mail my flyer/brochure which more fully describes my services and fees, and confirms their appointment.

INITIAL CONTACT & GUIDELINES
FOR CONDUCTING THE SESSION

The next stage of contact is the beginning of the actual session, after I have calculated and completed my preliminary synthesis of the chart and prepared notes which will enable me to more effectively utilize the material. I personally find such note-taking essential, in order to grasp the basic issues in a chart and to avoid having to struggle to do the first stages of interpretation while simultaneously engaging in dialogue with the client.

When the client arrives, some social conversation is usually necessary in order to establish rapport and help her feel at ease. Discussion of the weather, traffic or offers of coffee or tea may be followed by more personal questions. How does she feel about being here? Many clients are anxious, fearful of what I will tell them. Does she have any fears or anxieties, and would it be helpful to address them? Has she had any other thoughts in regard to issues she would like to discuss in this session? If the client has never had her chart interpreted, I give her a copy of her chart, usually delineated with keywords to describe its primary factors, and explain in rudimentary terms the nature and interaction of planets, signs, houses and aspects. I then briefly summarize again my approach to astrology and present my process for conducting a session—a process which usually involves brief monologues on my part, time out for questions and answers, another delineation period, questions and answers, etc. This process varies, for I encourage the client to interrupt me when she doesn't understand what I am saying, or has questions or feedback. Sometimes, such interruptions lead to in-depth focus upon a particular issue, or time periods during which the client expresses her concerns at length or vents her emotions. Such time for emotional expression is essential, particularly if the client is in crisis and unable to intellectually assess her situation or be receptive to new

understandings until she has discharged the feelings and tensions locked up within her.

Each session varies in nature, in accordance with the temperament and needs of the client, and often my own mood that particular day. Some clients speak continually, and as a result I cover much less material than planned; sometimes I choose to ask them, as tactfully as possible, how they prefer to use the time. Others are inhibited and reserved and hesitate to volunteer information or questions; they may need to be drawn out or allowed to maintain their privacy. Several guidelines which influence my own process in conducting an astrological session include:

1) Keep the original goals for the session in mind at all times.

2) Be prepared to abandon or modify those goals if more pressing needs arise.

3) Be alert to the client's physical and emotional expressions, particularly any signs of discomfort, and respond to them. Pay attention to what is going on in the here-and-now, or the emotional effectiveness of the consultation will be sacrificed.

4) Attempt to strike a balance between in-depth discussion of a few major issues and an imparting of information which may be processed more fully later when the client replays the tape.

5) Respect the client's belief system. Don't assume, for example, that because she has 12th house planets, and you are interested in past lives, that focusing upon past lives is the best approach to interpreting her 12th house planets. She may not even believe in reincarnation.

6) Be aware that when the client's immediate issues and feelings are pressing, you may need to focus upon them and modify your plans to interpret all of the key factors you noted in her chart beforehand. A brief glimpse at current transits can be useful during your initial preparation period, even if you are not intending to mention transits during the session.

7) Ask questions in order to ascertain how the client expresses certain facets of herself, and how the information you are imparting specifically applies to her. Not only will this help her integrate the material—you will learn, too!

8) After presenting an interpretation, give your client the opportunity for feedback and questions. Information, without assimilation time, is useless, and lacks emotional impact.

9) When in doubt about whether to continue in depth with a particular focus presented by either you or the client or to shift focus in order to cover more material, ask your client her preference. Let her choose how she can best use the available time.

10) At the end of the session, summarize key points and allow 5 or 10 minutes for last-minute questions and answers. You may wish to ask your client to summarize what she gained from the session and what she particularly found useful about your work together. At this point, you might also want to mention your availability in regard to follow-up sessions, or refer your client to recommended psychotherapists or health practitioners if you believe she can benefit from such a referral or if she requests it. Developing such a resource list is advisable.

INTERPRETATION & ADVICE

Interpretation is the primary activity which most astrologers engage in, and which many astrologers equate with astrological counseling. Yet counselors and psychotherapists regard interpretation as only one of the skills they use with clients, and as a skill which must be utilized appropriately in order to be effective. Interpretation alone does not lead to insight or change. In order for an interpretation to have a significant impact, the client must be emotionally receptive and psychologically ready to apply that insight, develop personal associations to it, and allow it to influence subsequent attitudes and behaviors.

Steven Levy, in his book *Principles of Interpretation*, and Fred Pine in *Developmental Theory and Clinical Process* both discuss the uses of interpretation in counseling, and the importance of assessing its impact upon the client. As Pine and Levy demonstrate, whatever your intent, a person is likely to filter your interpretation through his or her own psychological process, and often to distort its meaning and add to it his own evaluations. He may hear your interpretation as a judgment or condemnation which threatens his self-esteem and devalues or humiliates him. He may experience it as a deprivation or disappointment because he is wanting emotional support rather than intellectual understanding. He may use it as a rationalization which enables him to continue old behaviors and avoid new attitudes and actions, and especially to continue a pattern of intellectualizing rather than experiencing and taking responsibility for his feelings.

On the other hand, a client may receive your interpretation positively, because you are paying attention to him and are therefore gratifying him. If he is an oral person, your interpretation may be a gift to be swallowed and incorporated—sometimes without digestion and assimilation. Interpretation may be a satisfying confirmation of the client's sense of reality, may be experienced as acceptance and therefore give permission to him to be who he is, or may awaken within him a new sense of reality and an expanded awareness of possibilities.

If you are concerned with really helping your client rather than merely feeding him information regardless of his capacity to apply it, then you may want to train yourself to pay attention to what your client does with your interpretation, and to help him to constructively assimilate it. Does he turn it into judgment? Does he use it to keep rationalizing his stance in life and to avoid taking action? Or does he allow it to open him to deeper insight which helps him to act more effectively?

DRAWBACKS & CONSTRUCTIVE
USES OF INTERPRETATION

Before we discuss constructive uses of interpretation, let us consider more fully the drawbacks of relying too heavily upon interpretation in astrological counseling, and in using interpretation inappropriately. First, we as astrologers may be relating less to the client than to the chart, without regard for the client's capacity to use the interpretation. Second, interpretation may be used to demonstrate our superiority or power, to boost our own egos; it may also mask our own hostility and judgment. Third, interpretation may create distance, preventing the emotional engagement and contact by which real impact and insight occurs. Fourth, interpretation can be used indefinitely to intellectualize about, rather than actively and emotionally confront and deal with, real here-and-now issues. Interpretation can be a means of helping a client avoid taking responsibility and committing himself to constructive behavior patterns.

Still other drawbacks exist. We as astrologers, backed by the supposed authority of the birthchart, may too hastily draw conclusions, presenting one interpretation after another as gospel truth, overwhelming the client and devaluing him by not allowing him to participate in or confirm these self-definitions. When we rely heavily upon interpretation, we may be operating from the illusions that: 1) intellectual understanding alone elicits growth and change, and that 2) our imparting of information elicits growth and change. These assumptions need to be examined in the light of psychological theories which focus upon the necessary links between understanding, emotional receptivity and the psychological readiness to actively utilize an insight. It is important to consider also the profound impact of an insight we gain from within ourselves in contrast to an intellectual interpretation presented by another person. Someone else's interpretation may indeed trigger an experience of insight for us, but the interpretation alone is ineffective if its timing is inappropriate. Clients may be resistant to an interpretation or to too many interpretations when their anxiety level is high, when important emotional

needs are unmet, and when they are deeply involved with a particular emotional crisis or issue which is currently center stage in their lives. In such cases, we need to limit the number of interpretations we present, choose our words carefully, and pay attention to our client's capacity to assimilate and use that interpretation to gain useful insight for himself.

Interpretation is indeed valuable when imparted with acceptance and sensitivity to a client's psychological state. It may help him to conceptualize and clarify vague feelings and behavior patterns, and therefore in time gain mastery over them. By increasing the realm of the ego over the id or unconscious, a person becomes more conscious of himself and therefore more capable, when he so chooses, of directing his actions. Interpretation can help clients realize when they are operating from outdated or inappropriate assumptions or behavior patterns, which, when understood, may be more easily relinquished. Interpretations can also help clients define and reorganize their sense of themselves and their reality, in order to feel more solid and more capable. Some interpretations help clients become aware of other perspectives, attitudes, choices and actions so that their range of behaviors is increased and the possibilities open to them expanded. Much depends upon whether an interpretation is worded negatively or positively, designed to impart "this is what you are," as if we are fixed entities completely determined by past conditioning and astrological factors, or whether an interpretation imparts that "this is what you have been. . . and this is what you can be."

INTERPRETATION: WHAT, WHEN & HOW?

WHAT should we as astrologers interpret? First, the most significant factors and issues as reflected by the chart—the most basic needs, motivations, weaknesses, conflicts, strengths and possibilities. Second, what is currently most emotionally relevant and useful to the client. Attention should be paid to both *HOW MUCH* to interpret (so as not to overwhelm the client) and the sense of validity or certainty that we experience in regard to an interpretation. Presenting many uncertain

or doubtful interpretations weakens the impact of those which deeply resonate with our client's experience.

WHEN should we interpret? Because we use interpretation so heavily in astrological work, we cannot be as sensitive as mental health counselors and therapists might be to the client's emotional readiness. Some of our interpretations which are not apparently received at the time may be heard more deeply later when the tape is replayed, or even months or years later when the tiny seed we have planted is watered by future experiences and germinates. Nevertheless, guidelines for timing interpretations include: a) when the client is relaxed and open, and trust has been established; b) when the client has expressed his feelings and concerns, and no longer is preoccupied with undischarged emotion; c) when the client has already expressed a portion of a particular understanding and is groping for deeper insight in regard to this issue.

HOW should we phrase our interpretations? First, we need to communicate emotionally, by our posture, gestures, facial expression and voice, an attitude of acceptance. Second, we can benefit our client most by suggesting rather than telling, presenting an interpretation tentatively so that a client is free to accept or reject it and to further elaborate upon it. This of course requires that we give up that aura of authority which may provide us and our clients with a reassuring but false sense of security. Of deeper value in the long run, however, is our willingness to engage our client in mutual exploration as we present questions and statements which are interpretative. (For example, questions such as, "Do you sometimes find yourself doing x? What's that like?" And statements such as, "This planetary pattern suggests that you tend to do x in this area of your life. I'm wondering how you experience that tendency.") Sometimes presenting a general interpretation and asking for feedback can allow you and your client together to discover specific patterns which can lead to useful insight and action.

Because of the large number of meanings for each astrological position and the various levels at which a client may

be experiencing and expressing particular influences, we may wish to present a wide range of possibilities when describing a particular planetary position, aspect or configuration. For example, a t-square to Neptune in Libra in the 9th house may suggest an urge to "get high," but does this person attempt to transcend himself through drugs, meditation, travel or spiritual experience? We might say to this client: "You are likely to experience a deep yearning and desire to transcend yourself, an urge to 'get high' in some manner. This could lead you to turn to drugs or lose yourself in fantasy, or it might also incline you to meditate, to become involved with spiritual pursuits, to study music or teach music or literature, or even to travel to inspiring places. You would be particularly drawn to places which are spiritual or idyllic, places which are on the water or which possess a natural beauty. Do any of these alternatives particularly appeal to you?" Later, after our client has confirmed several of our impressions, we may ask if he has considered any of the other options which we have presented.

How do we know when an interpretation resonates with our client's experience and is being fully received by him? First, he may indicate by gestures or facial expressions that he has been touched and affected. Second, he may respond verbally with associations and further elaborations. If he does not react at all, we may be inaccurate in our interpretation or ineffective in our wording or translation of planetary positions; on the other hand, our interpretation may be accurate, but have no emotional impact for the client at present because it is too superficial, or because it presents something which he already knows or something which he is not yet capable of hearing. If a client denies or resists our interpretation, several explanations are possible. You may have touched a sensitive point which he is not ready to face—in which case, we may wish to drop the issue since we are not therapists and may have little to gain from further probing. There is always the chance that he will be more receptive when he is alone replaying the tape of the session. On the other hand, we may be inaccurate in our interpretation of astrological symbols or mistakenly assume that the client is operating

from too low or too high a level of consciousness or action. Active denial does not necessarily indicate the truth of what we are imparting; sometimes people ardently resist an interpretation, not because it is too truthful, but because we have trod upon aspects of themselves which they cherish, and they are angry or hurt in response to being misinterpreted and misunderstood.

ADVICE-GIVING
IN ASTROLOGICAL COUNSELING

The issue of giving advice is an important one for us astrologers to consider, particularly because we wish to help our clients and because advice-giving is considered by many to be a primary mode of giving help. Advice-giving, like interpretation, has both negative and positive manifestations.

Advice may be imparted from a one-up position, suggesting that we know specifically how a person should act; however, he knows himself and what works for him far better than we ever will. Our advice may be too simplistic or similar to suggestions which he has heard repeatedly, and which he experiences as an annoyance or intrusion. Some people, especially those with parents who were compulsive advice-givers (or who possess a prominent and afflicted Uranus) may resist immediately when advice is presented, whether the advice is useful or not, simply because they experience it as unwanted interference. Advice sometimes sets up a "yes but" interaction with a client who is obviously not ready for or willing to take action. It may instigate a situation of dependency with a client who is all too willing for you to take responsibility for solving his problems. It may prevent him from becoming motivated to develop his own ideas and may give him an excuse to blame you if he so chooses to use your advice and does not profit by it. Finally, in giving advice, you may be assuming that your client has the time, energy, money and/or inner resources to utilize it. If he does not, your advice may spark his feelings of inadequacy, deprivation or hopelessness. Often, when a client seeks advice he is in more need of discovering HOW to resolve a particular

difficulty than in determining WHAT indeed he needs to do. Defining the WHAT is considerably easier than facilitating the HOW.

When is advice helpful? First of all, your advice is likely to be helpful when your client really feels that you are with him, that you understand his reality and his capacities, as well as the options he has already tried, and you have been jointly exploring new possibilities. Advice may be useful when you sense that your client is clearly open to receiving it, and both capable of applying it and eager to do so. After you have asked him his perceptions of his options and he has indicated some, but is unaware of others which might be beneficial to him, your suggestion might indeed be worthwhile. This is particularly true when he obviously has the necessary resources to act upon it. Frequently, people are most capable of receiving and utilizing advice when it is imparted indirectly. Rather than saying, "you *should* do this" (which is never recommended) or "you might want to try this," you might instead tell an anecdote about how you or another person benefitted from a particular course of action. Such stories usually inspire and motivate people far more effectively than direct advice.

COUNSELING INTERVENTIONS

If you have not been trained as a counselor, then you may not have developed the art of asking questions or making statements which facilitate insight, growth and change. Indeed, even if you have had training as a counselor, your repertoire of responses may be limited by the nature of your training. Developing such a repertoire does not have to require years of counseling training and experience. Sometimes, all you need is an inquiring mind, willingness to explore how a client functions, and the desire to help a client discover and actualize new modes of being.

I personally have found value in compiling a list of statements and questions which are useful in both psychotherapeutic and astrological counseling, and in consciously practicing

these interventions whenever appropriate. Most of the counseling interventions on the following pages can be utilized constructively in astrological consultations; many are particularly effective in encouraging client self-direction and responsibility. Such a list may indeed be a gold mine for beginning astrologers intent upon improving counseling skills.

**

USEFUL COUNSELING INTERVENTIONS

OPEN-ENDED QUESTIONS AND STATEMENTS

What's coming up for you?
What's that like for you?
How do you experience that?
Are you willing to share what's happening for you?
What does this mean to you?
How is this reflected in your life?
How does this relate to your life?
Do you have any examples from your own life?
As I talk, what are you aware of experiencing?
Tell me what this means to you.
How is this true or not true for you?
Is there anything you want to share about this?

DEEPENING EXPERIENCE

Tell me more about that.
Stay with your experience.
Stay with your feelings.
Take a moment to tune into yourself.
What's it like to feel that?
Let yourself experience that and see what else comes up for
 you.
Let yourself breathe more fully, and see if you can get more
 deeply in touch with yourself.
Just let yourself be with that, and see what comes up for you.

USEFUL COUNSELING INTERVENTIONS, continued

FURTHER EXPLORATION

What would happen if you . . . ?
What would happen then?
Can you imagine how you might do x?
If you were to do x, what might you experience?
Do you have a sense of how doing x might change your life?
Can you get in touch with any other benefits you might gain from doing x?
What other alternatives are you aware of?
What other alternatives have you tried?
How would you most like to express that energy?
Where would you like to be ten years from now in regard to that issue?
If none of those obstacles existed, what might your goals be?

ACTION AND APPLICATION

How might you bring more of x into your life?
How might you do that?
What would help?
Do you have a sense of where you want to be with that?
How can you use/apply that awareness?
What do you want to do about it?
What would it take for you to reach that goal?
What plan of action might you form?
How might you go about doing that?

EXPLORING AND OVERCOMING OBSTACLES

What's stopping you?
What might stop you?
What are you getting out of being stuck?
What obstacles might come up for you?
How might you stand in your own way?
How can you prepare yourself for those obstacles/problems?
If you had the answers, what might they be?
Who in you might interfere with your goal?
How might you prevent that from happening?

USEFUL COUNSELING INTERVENTIONS, continued

EXPLORING AND OVERCOMING OBSTACLES, continued

What might keep you from following through?
What other parts of you might get in the way and prevent change?
How can you prevent your inner saboteurs from sabotaging your actions?
How might you overcome those obstacles?
What supports do you need to maintain your will?

CHANGING COGNITIVE STRUCTURES

What other attitudes might you take toward that experience?
How could you view that experience positively?
What are you not seeing?
What are you avoiding facing?
Do you see any assumptions which are influencing you?
How might you have viewed this situation five years ago?
What do you get out of holding this view of your situation?
Can you imagine any other ways of viewing this situation?
What if you sit over here (across the room) and look at the space where you were sitting before? What do you, as observer, have to say about the attitudes and actions of the person who was sitting there?
Are there any other ways available to you to describe that situation? How might you reframe it?

ACKNOWLEDGING POLARITIES/BUILDING
AN INTEGRATING CENTER

What if you let yourself experience both parts of yourself?
If part x had a voice, what would it say? What about part y?
What's it like to be aware of both at the same time?
What might part x say to part y? Part y to part x?
Take a few moments and dialogue between these two parts of you.
Would you be willing to let me play the role of part x and dialogue with you as part y?

USEFUL COUNSELING INTERVENTIONS, continued

ACKNOWLEDGING POLARITIES/BUILDING AN INTEGRATING CENTER, continued

Take a moment to experience both parts of yourself and the conflict between them, and see if you can get any insight about how to satisfy both of them.

What alternatives might satisfy both part x and part y?

FACILITATING SELF-DIRECTION IN THE MOMENT

What's your sense of what needs to happen here?

Which of these alternatives would you like to focus upon?

What do you feel you need to do now?

Where would you like to focus for the rest of the session?

Would you rather explore this issue in more depth or cover more material?

What feels like it needs to happen before we stop?

Why don't you share the main insights you've gained so far and we'll see if there's anything else we need to clarify before we move on.

How would you like to use the rest of the time?

REFLECTIVE COMMENTS

Sounds like you . . .

I get the impression that you . . .

It seems to me that you are feeling . . .

I hear you saying that . . .

I imagine you might be experiencing . . .

Are you saying that . . . ?

You're experiencing that . . .

You're wondering if . . .

You're feeling that . . .

AFFIRMING RESPONSES

Sounds great.

That's good.

Wonderful!

USEFUL COUNSELING INTERVENTIONS, continued

AFFIRMING RESPONSES, continued

Right on!

Sounds like you're really in touch with this part of you.

Sounds like you're on the right track.

You really do seem to be on the path your chart indicates.

You're really starting to come to terms with that issue.

You obviously have a good handle on that issue.

I get the impression that you've overcome that problem.

CONFRONTING PASSIVITY
OR LACK OF RESPONSIBILITY

You don't seem to be willing to take much responsibility for changing that. I'm wondering what's keeping you from acting.

Sounds like you're expecting the world to meet your expectations, to give you what you want without having to put out any effort.

If you don't go after what you want, how do you expect to get it?

What are you getting out of being passive? Do you imagine that it's all just going to come to you?

What might you gain if you were willing to develop more motivation?

Are you expressing some anger at somebody by refusing to act?

I have the impression that you're on a sit-down strike. You're expressing your anger at the injustice of it all by refusing to act.

As long as you continue to blame him, you can keep your anger tied up with him, rather than harnessing it and directing it toward making a change yourself.

What might help empower you?

If you put the positive meaning of that planet into effect, you're less likely to experience its negative meaning. What's keeping you from doing so?

USEFUL COUNSELING INTERVENTIONS, continued

CONFRONTING PASSIVITY
OR LACK OF RESPONSIBILITY, continued

What do you imagine you're gaining by refusing to act?

I hear you presenting a variety of excuses, and am wondering if you really want to change.

I get the impression that you're waiting for somebody to rescue you and that you don't want to take much responsibility for making your life work. Do you think that's true?

**

YOUR ASTRO-COUNSELING ISSUES
A WORKSHEET

1. What is your major problem or deficiency in regard to astrological counseling?

2. How does this problem manifest itself?

3. What effect does this problem have upon yourself and others?

4. What keeps you repeatedly encountering this problem?

5. Where do you want to be in relation to this problem? What is your goal?

6. What attitude or behavior would you have to change or give up in order to resolve this problem?

7. Why do you want to resolve this problem? What would you gain by resolving it?

8. What are you getting out of being stuck or unresolved?

9. What do you need to do in order to reach your goal?

10. What obstacles do you foresee or what sacrifices might you have to make to fulfill your goal?

11. How motivated are you to move toward your goal? How important is it in relation to your other priorities?

12. What is one small step you might take in the next week? How can you begin NOW to progress toward your goal?

Afterword

You possess within yourself
The vision of the whole,
The inner synthesis.

You have it all,
All that you are seeking.

Whether by planet,
House cusp
Or house interception,
You have all of the signs.

You ARE all of the signs.

You need only to know it,
And to become
Whom you already are.

You are one and you are many
You are part and you are whole.

Disorganized and organized,
Analyzed and synthesized,
Separated and unified.

You are Libra, Gemini, Leo.
 Virgo, Cancer, Scorpio.
You are Taurus, Capricorn, Aquarius.
 Aries, Pisces, Sagittarius.

This you now know.
This you have heard.
Wake then, and go.
Drop your role,
Follow your soul.
Spread the word.
We are all whole.

Bibliography

Arroyo, Stephen, *Astrology, Karma and Transformation*, CRCS Publications, Reno, Nevada, 1978.

Garfinkel, Bernie, *Liv Ullman And Ingmar Bergman*, Berkeley Press, New York, 1976.

Hand, Robert, *Horoscope Symbols*, Para Research, Inc., Rockport, Mass. 1981.

Hughes, Robert, *The Sun And Moon Polarity In Your Horoscope*, American Federation of Astrologers, Tempe, Arizona, 1977.

Jansky, Robert Carl, *Horoscopes: Here And Now*, Astro-Analytics, Van Nuys, California, 1975.

Jansky, Robert Carl, *Interpreting The Aspects*, Astro-Analytics, Van Nuys, California, 1974.

Jansky, Robert Carl, *Interpreting The Eclipses*, Astro-Analytics, Van Nuys, California, 1975.

Jayne, Charles, *Horoscope Interpretation Outlined*, Astrological Bureau, Monroe, New York, 1975.

March, Marion and McEvers, Joan, *The Only Way To Learn Astrology*, Volume II, ACS Publications, San Diego, California, 1980.

Marks, Tracy, *Astrology Of Self-Discovery*, CRCS Publications, Reno, Nevada, 1985 (incorporates revised booklets published previously by Sagittarius Rising).

Marks, Tracy, *How To Handle Your T-Square*, Sagittarius Rising, Arlington, Mass., 1979. (Re-published in revised edition by CRCS Publications under the title *Planetary Aspects: From Conflict to Cooperation.*)

Marks, Tracy, *The Twelfth House*, Sagittarius Rising, Arlington, Mass., 1978.

Meyer, Michael, *A Handbook For The Humanistic Astrologer*, Anchor/Doubleday, New York, 1974.

Rudhyar, Dane, *An Astrological Mandala*, Random House, Garden City, New York, 1974.

Rudhyar, Dane, *The Lunation Cycle*, Shambhala, Berkeley, California, 1971.

Rudhyar, Dane, *Person-Centered Astrology*, Aurora Books, New York, 1976.

Tierney, Bil, *Dynamics Of Aspect Analysis: New Perceptions In Astrology*, CRCS Publications, 1983.

Ullman, Liv, *Changing*, Alfred A. Knopf, New York, 1977.

Van Toen, Donna, *The Astrologer's Node Book*, Samuel Weiser, Inc., York Beach, Maine, 1981.

COUNSELING BIBLIOGRAPHY

The following books discuss the process of chart interpretation from a counseling perspective:

Alexander, Roy, *The Astrology Of Choice: A Counseling Approach*, Samuel Weiser, Inc., York Beach, Maine, 1983.

Arroyo, Stephen, *The Practice And Profession Of Astrology*, CRCS Publications, Reno, Nevada, 1984.

Pottenger, Maritha, *Healing With The Horoscope*, ACS Publications, San Diego, California, 1982.

Rosenblum, Bernard, *The Astrologer's Guide To Counseling*, CRCS Publications, Reno, Nevada, 1983.

BOOKS BY TRACY MARKS

THE ASTROLOGY OF SELF-DISCOVERY: An In-depth Exploration of the Potentials Revealed in Your Birth Chart . . . 288-page paperback, packed with information! .. **$9.95**
A guide to utilizing astrology to aid self-development and self-knowledge, to resolve inner conflicts, discover and fulfill one's life purpose, and to realize one's potential. Emphasizes the Moon and its nodes, Neptune, Pluto, and the outer planets' transits. An important and original work!

THE ART OF CHART INTERPRETATION: A Step-by-Step Method of Analyzing, Synthesizing & Understanding the Birth Chart . . . 180-page paperback . . . a must for students! **$7.95**
A great value and a great book, this is a revised, expanded version of the author's book on Chart Synthesis. It is a guide for determining the most important features of any birth chart; there is no book like it! Includes worksheets that allow the reader to systematically evaluate the patterns and themes of any chart.

PLANETARY ASPECTS—FROM CONFLICT TO COOPERATION: How to Make Your Stressful Aspects Work for You . . . 228-page paperback . . . a best-selling classic! **$11.95**
This new edition of *How to Handle Your T-Square* focuses on the creative understanding and use of the stressful aspects and emphasizes the T-Square Configuration both in natal charts and as formed by transits and progressions. The most thorough treatment of these subjects in print! Includes techniques for handling these challenges.

YOUR SECRET SELF: Illuminating the Mysteries of the Twelfth House . . . 264 pages **$12.95**
The most comprehensive treatment of the 12th House and its subtleties ever published. The importance of the 12th House for self-knowledge and the dimensions of psychological and spiritual potential that it symbolizes are emphasized. It also demonstrates in a fascinating way how the themes of a birth chart emerge in one's dreams and how working with dreams is one of the most effective gateways into the hidden meanings of the 12th House.

C·R·C·S BOOKS

THE ANCIENT SCIENCE OF GEOMANCY: Living in Harmony with the Earth by Nigel Pennick $14.95. The best and most accessible survey of this ancient wholistic art/science superbly illustrated with 120 photos.

AN ASTROLOGICAL GUIDE TO SELF-AWARENESS by Donna Cunningham, M.S.W. $8.95. Written in a lively style, this book includes chapters on transits, houses, interpreting aspects, etc. A popular book translated into 5 languages.

THE ART OF CHART INTERPRETATION: A Step-by-Step Method of Analyzing, Synthesizing & Understanding the Birth Chart by Tracy Marks $8.95. A guide to determining the most important features of a birth chart. A must for students!

THE ASTROLOGER'S MANUAL: Modern Insights into an Ancient Art by Landis Knight Green $12.95, 240 pages. A strikingly original work that includes extensive sections on relationships, aspects, and all the fundamentals in a lively new way.

THE ASTROLOGICAL HOUSES: The Spectrum of Individual Experience by Dane Rudhyar $10.95. A recognized classic of modern astrology that has sold over 100,000 copies, this book is required reading for every student of astrology seeking to understand the deeper meanings of the houses.

ASTROLOGY: The Classic Guide to Understanding Your Horoscope by Ronald C. Davison $8.95. The most popular book on astrology during the 1960s & 1970s is now back in print in a new edition, with an instructive new foreword that explains how the author's remarkable keyword system can be used by even the novice student of astrology.

ASTROLOGY FOR THE NEW AGE: An Intuitive Approach by Marcus Allen $7.95. Emphasizes self-acceptance and tuning in to your chart with a positive openness. Helps one create his or her own interpretation.

ASTROLOGY IN ACTION: How Astrology Works in Practice, Demonstrated by Transits, Progressions & Major Chart Themes in Famous People's Lives by Paul Wright $12.95. Penetrating exploration of astrological symbolism. Includes the charts of Woody Allen, Brando, Prince Charles, Sean Connery, Cezanne, Dylan, Lennon and many more.

ASTROLOGY IN MODERN LANGUAGE by Richard Vaughan $12.95, 336 pages. An in-depth interpretation of the birth chart focusing on the houses and their ruling planets — including the Ascendant and its ruler. A unique, strikingly original work.

ASTROLOGY, KARMA & TRANSFORMATION: The Inner Dimensions of the Birth Chart by Stephen Arroyo $12.95. An insightful book on the use of astrology for personal growth, seen in the light of the theory of karma and the urge toward self-transformation. International best-seller! New edition, now with comprehensive index!

THE ASTROLOGY OF SELF-DISCOVERY: An In-Depth Exploration of the Potentials Revealed in Your Birth Chart by Tracy Marks $12.95, 288 pages. Emphasizes the Moon and its nodes, Neptune, Pluto, & the outer planet transits. An important and brilliantly original work!

ASTROLOGY, PSYCHOLOGY AND THE FOUR ELEMENTS: An Energy Approach to Astrology & Its Use in the Counseling Arts by Stephen Arroyo $9.95. An international best-seller. Clearly shows how to approach astrology with a real understanding of the energies involved. Awarded the British Astrological Assn's Astrology Prize. A classic translated into 8 languages!

TEPHEN ARROYO'S CHART INTERPRETATION HANDBOOK: Guidelines for Understanding the Essentials of the Birth Chart $9.95. Shows how to combine keywords, central concepts, and interpretive phrases in a way that illuminates the meanings of the planets, signs, houses, and aspects emphasized in any chart.

.YCLES OF BECOMING: The Planetary Pattern of Growth by Alexander Ruperti $15.95, 274 pages. The first complete treatment of transits from a humanistic and holistic perspective. All important planetary cycles are correlated with the essential phases of personal development. A pioneering work!

YNAMICS OF ASPECT ANALYSIS: New Perceptions in Astrology by Bil Tierney $12.95, 288 pages. Ground-breaking work! The most in-depth treatment of aspects and aspect patterns available, including both major and minor configurations. Also includes retrogrades, unaspected planets & more!

JOURNEY THROUGH THE BIRTH CHART: Using Astrology on Your Life Path by Joanne Wickenburg $7.95. Gives the reader the tools to put the pieces of the birth chart together for self-understanding and encourages creative interpretation by helping the reader to think through the endless combinations of astrological symbols.

IEW INSIGHTS IN MODERN ASTROLOGY by Stephen Arroyo & Liz Greene $10.95. Deals with myth, chart synthesis, relationships, & Jungian psychology related to astrology. A wealth of original ideas!

HE LITERARY ZODIAC by Paul Wright $14.95, 240 pages. A pioneering work, based on extensive research, exploring the connection between astrology and literary creativity.

IUMBERS AS SYMBOLS FOR SELF-DISCOVERY: Exploring Character & Destiny with Numerology by Richard Vaughan $8.95, 336 pages. A how-to book on personal analysis and forecasting your future through Numerology. Examples include the number patterns of a thousand famous personalities.

HE OUTER PLANETS & THEIR CYCLES: The Astrology of the Collective by Liz Greene $12.95. Deals with the individual's attunement to the outer planets as well as with significant historical and generational trends that correlate to these planetary cycles.

'LANETARY ASPECTS – FROM CONFLICT TO COOPERATION: How to Make Your Stressful Aspects Work for You by Tracy Marks $11.95, 225 pages. This revised edition of HOW TO HANDLE YOUR T-SQUARE focuses on the creative understanding of the stressful aspects and focuses on the T-Square configuration both in natal charts and as formed by transits & progressions. The most thorough treatment of these subjects in print!

HE PLANETS AND HUMAN BEHAVIOR by Jeff Mayo $9.95. A pioneering exploration of the symbolism of the planets, blending their modern psychological significance with their ancient mythological meanings. Includes many tips on interpretation.

HE PRACTICE AND PROFESSION OF ASTROLOGY: Rebuilding Our Lost Connections with the Cosmos by Stephen Arroyo $7.95. A challenging, often controversial treatment of astrology's place in modern society and of astrological counseling as both a legitimate profession and a healing process.

REINCARNATION THROUGH THE ZODIAC by Joan Hodgson $7.95. A study of the signs of the zodiac from a spiritual perspective, based upon the development of different phases of consciousness through reincarnation.

RELATIONSHIPS & LIFE CYCLES: Modern Dimensions of Astrology by Stephen Arroyo $10.95. Thorough discussion of natal chart indicators of one's capacity and need for relationship, techniques of chart comparison, & using transits practically. New edition, now with a comprehensive index.

;EX & THE ZODIAC: An Astrological Guide to Intimate Relationships by Helen Terrell $9.95, 256 pages. Goes into great detail in describing and analyzing the dominant traits and needs of women and men as indicated by their Zodiacal signs.

A SPIRITUAL APPROACH TO ASTROLOGY by Myrna Lofthus $14.95, 444 pages. A complete astrology textbook from a karmic viewpoint, with an especially valuable 130-page section on karmic interpretation of all aspects, including the Ascendant & MC.

YOUR SECRET SELF: Illuminating the Mysteries of the Twelfth House by Tracy Marks A Guide to Using Astrology & Your Dreams for Personal Growth. $12.95. This important book demonstrates how working with dreams is one of the most effective gateways into the hidden meanings of the Twelfth House.

CHINESE VEGETARIAN COOKERY by Jack Santa Maria $9.95. *VEGETARIAN* magazine called this "the best" of all the books on Chinese vegetarian cookery. It is by far the most accessible for Westerners and uses ingredients that are easily found anywhere.

HEALTH BUILDING: The Conscious Art of Living Well by Dr. Randolph Stone $10.95. A complete health program for people of all ages, based on vital energy currents. Includes instructions on vegetarian & purifying diets and energizing exercises for vitality & beauty

CATCHING GOOD HEALTH WITH HOMEOPATHIC MEDICINE: A Concise, Self-Help Introduction to Homeopathy by Raymond J. Garrett & TaRessa Stone $8.95. Includes dozens of fascinating personal stories of striking cures, as well as guidelines to choosing effective remedies for first-aid and sports injuries.

POLARITY THERAPY: VOL. I & II: The Complete Collected Works by Dr. Randolph Stone D.O., D.C. $30.00 each. The original books on this revolutionary healing art, available for the first time in trade editions. Fully illustrated with charts & diagrams. Sewn binding.

PROTEIN-BALANCED VEGETARIAN COOKERY by David Scott $9.95, 184 pages. The only cookbook that focuses on the crucial issue of protein balance and protein-sufficiency.

TAI CHI: TEN MINUTES TO HEALTH: The Most Comprehensive Guide to Yang Tai Chi by Chia Siew Pang & Goh Ewe Hock $16.95, 132 pages. The most comprehensive manual Yang style Tai Chi available, which breaks down the movements in more detail than any other book. Recommended by American Library Association's "Booklist."

For more complete information on our books, a complete catalog, or to order any of the above publications, WRITE TO:

CRCS Publicatio
Post Office Box 14
Sebastopol, California 954
U.S